BRITAIN IN OLD PHO

C000246616

Newton Abbot

DEREK BEAVIS

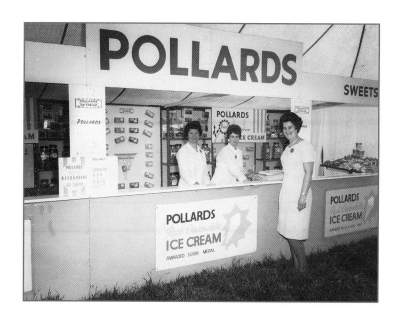

SUTTON PUBLISHING LIMITED

Sutton Publishing Limited
Phoenix Mill · Thrupp · Stroud
Gloucestershire · GL5 2BU

First published 2000

Title page: Pollard's confectionery and ice cream on display at a trades fair at Newton Abbot Racecourse in the late 1960s. Included in the picture are Mrs Margaret Sanders (née Pollard) and Mrs Kathleen Pollard, obviously proud to display their silver medal award status.

British Library Cataloguing in Publication Data
A catalogue record for this book is available from the British Library.

ISBN 0-7509-2529-9

Typeset in 10.5/13.5 Photina.
Typesetting and origination by
Sutton Publishing Limited.
Printed and bound in England by
J.H. Haynes & Co. Ltd, Sparkford.

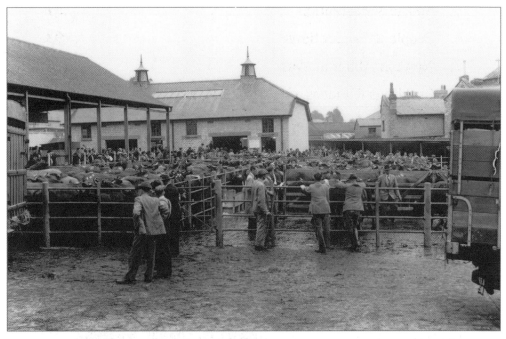

The status of Newton Abbot as a flourishing market town extends back to the thirteenth century when both Newton Abbot and Newton Bushel were granted charters for holding weekly markets. Newton Abbot's market was held in Wolborough Street while that of Newton Bushel was held on the small piece of land behind St Mary's, known as Trigle Hill. A conflict for control of the markets arose in the seventeenth century when William Waller of Forde tried to wrest them from the Yardes of Bradley. Although his plan was thwarted at the time the two markets eventually amalgamated, and in 1826 the market was moved to its present site on Lydis Meadow. In 1906 Newton Abbot Urban Council acquired more land to accommodate the livestock market and in 1938 the area was enlarged, with the cattle being separated from the pigs and sheep. This picture from the 1950s features the cattle auction. As can be seen, most of the cattle were still horned.

CONTENTS

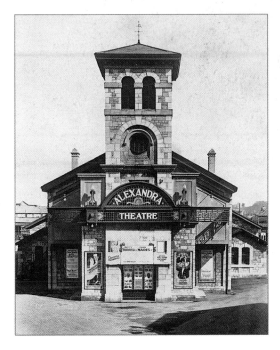

The stage of the Alexandra Hall, built in 1871, has provided Newton Abbot with a wide variety of entertainment. Operas, repertory, musicals and dramas have all attracted huge crowds. For most of its life it has also competed as the poor relation against two contemporary cinemas, the Odeon and the Imperial, but now it alone remains.

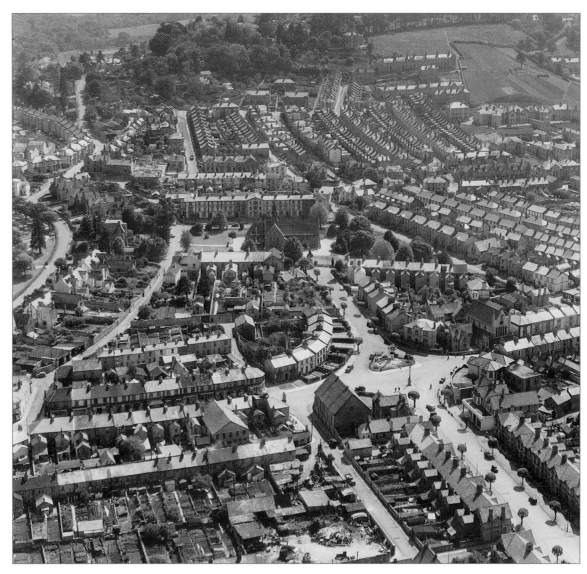

This aerial view shows how the town looked in the 1950s. The central feature is obviously the war memorial in Queen Street, which helps us to identify the surrounding roads. The outstanding contrast with modern photos is the lack of traffic. One might feel that the photo was taken early in the morning when few people were about, but when one considers the crisp definition and looks a little more closely at the shadows cast, it becomes clear that the sun is shining from the west, which indicates that the picture was most likely taken in the afternoon or early evening.

INTRODUCTION

What, in your mind, constitutes a successful warm community? When does it earn for itself the right to be categorised as a town? Is its success measured only by its prosperity, or when it is accepted by others as a thriving society? Just how big a part is determined by its history, its people, its location or even its climate? Actually, it is a combination of all these aspects coming together into a united whole. All these features of life in Newton Abbot can be traced.

Steeped in history, which can be traced with certainty back to the twelfth century, Newton Abbot has offered stability and roots to its inhabitants while at the same time it has always been forward looking, with plans being constantly made for its further development and benefit. The iron-age fort behind Bradley Manor and the Celtic fort which bisects St Marychurch Road offer proof that even before the Norman Conquest people were drawn to this delightful valley, through which the River Lemon meanders as it wends its way from Dartmoor to meet its big sister, the Teign. No doubt those early settlers sought shelter from the severe weather rolling across the moors, while at the same time they desired to live far enough inland to avoid the ravages of the sea. The town's location also made it a crossing point for travellers between Exeter and the coastal towns and those journeying between Exeter and Plymouth, as can be verified by the portion of Roman road which runs across Teignbridge, just outside the town. At the time of the Conquest it is clear that a castle, possibly a wooden structure, stood in Highweek, then known as Teignwick; the area became a prize possession for the king, and was later inherited by the Bushel family.

The towns of Newton Abbot, Newton Bushel and Schirebourne Newton flourished side by side, until they were united in 1822. One of the major developments occurred in 1846 with the arrival of the railway and its many ancillary trades. However, even now, with the demise of its position as the leading railway town in the south-west, Newton Abbot continues to grow and prosper as it endeavours to appeal to visitor and resident alike.

Many attempts have been made to create a record of how the town grew, and there has been a call by many to collect all the information under one roof. Since her appointment in 1989 as curator of the town's museum, Mrs Felicity Cole and her team of volunteers have worked hard to present as much material as possible in an interesting and tasteful way. The museum has undergone great changes since it was first formed in 1983. At this time it was housed on the top floor of the Passmore

This is how Highweek Street looked until the 1960s. One can't help but imagine the difficulties such narrow streets and bottlenecks would cause now. On the right-hand side of the picture is St Mary's, with Chapel Hill leading down from Treacle Hill. Beside this stood a fish and chip shop with Abraham's sweet and confectionery shop next door. On the corner of Halcyon Road was a do it yourself store, opposite White's Garage. The garage was built on the site of Pinsent's Brewery, and even though the brewery had long since been converted many relics of the industry still remained until the buildings were demolished.

Edwards Library in Highweek Street. Sadly this location meant that many elderly and disabled people were denied access, since they found the climb to the top of the building an impossible task. Consequently it was with great enthusiasm that the museum was opened in July 1990, after almost a year's closure, in its current home adjoining the town hall in Devon Square.

A highlight came in 1992 when Newton Abbot Museum was given full registration by the Museum and Galleries Commission. This was quite an achievement since the certificate requires a high standard of documentation and presentation skills. The benefits of being so recognised mean that help can be acquired from the Area Museum Council for grant aid to help with purchasing and promoting important collections.

Those who visit the museum appreciate their 'step back in time' and after a few minutes in the building, absorbing the atmosphere, visitors often find themselves in a discussion of what things used to be like. Many collections are on display, such as photos and relics of the clay industry, the woollen mills, the railway, and the efforts of townspeople during the war years. From time to time there are special interest events when particular hobbies can be pursued. It is possible that the museum might be moving to new premises that are even more accessible, and it is hoped that many more Newtonians will be able to enjoy this amenity.

1

Newton's Changing Face

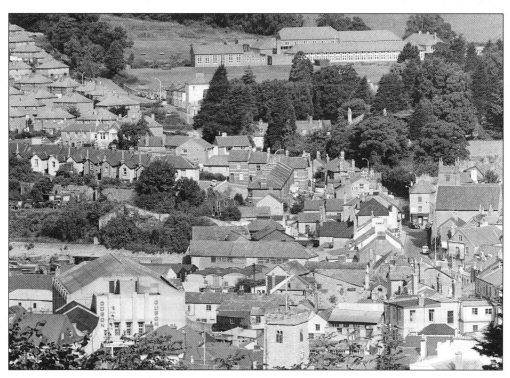

This view of the town from the 1950s is the one which many Newtonians nostalgically remember. St Leonard's Tower, in the foreground, built with its adjoining church in the thirteenth century, remains the focal point, appearing in most historical references to the town. Other landmarks have come and gone, such as the Odeon cinema in the left foreground. This cinema was opened on 13 February 1936 by Councillor Leonard Coombe, and until the 1970s was regarded as the main one of the three cinemas where many Newtonians sought solace and comfort during good times as well as during the war years. However, its life was short compared with its compatriots the Imperial and Alexandra, which featured plays and concerts on various occasions.

Other dramatic changes have occurred, with many buildings demolished to allow for street widening. In this picture we can see how different Highweek Street is in front of St Mary's, in the right middle distance. Highweek Secondary School for Girls, now Coombeshead Comprehensive, erected in 1940, can be seen in the distance, and behind it are the allotments which occupied the site of the present St Joseph's Catholic School. The clump of trees in front of the school hides Dyron's Field, once the property of the Vicary family, who allowed an annual fête to be held on Hospital Saturday.

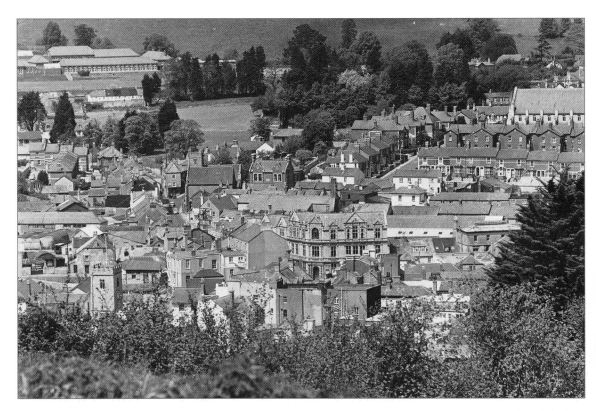

Looking slightly eastward, we can discern where more of the buildings in the foreground have been demolished, to make way for development as the post office complex. In the right middle distance is Abbotsbury Church, built in 1906 on the site of Abbotsbury House, the home of the Fisher family, after whom Fisher and Halcyon Roads were named – the latter is a play on words: a halcyon is a kingfisher. Mrs Emmeline Fisher was a great benefactor of Newton Abbot Hospital.

Opposite, below: Churchill's Estate now occupies all the area on the right of Pitt Hill, behind the wall in this picture from the 1950s. In the centre of the field can be seen the wall which stood beside Church Path (leading to All Saints' Church), which still exists. The field on the far left has now been developed, with many detached houses on the site.

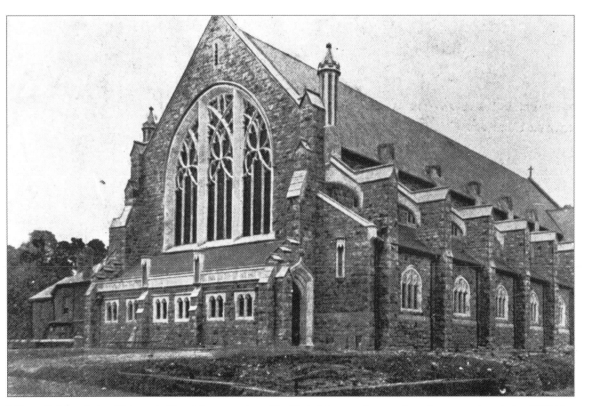

When St Mary's in Highweek Street became too dilapidated to use for services it was replaced, in 1906, by Abbotsbury Church. In September 1924 the stained glass window in the centre aisle, a gift from an anonymous donor, was dedicated. The following month the Lord Bishop of Exeter dedicated the elaborate reredos and choir stalls. Another memorable occasion was the service to commemorate twenty-seven old boys of Newton Abbot Grammar School who had lost their lives during the Second World War.

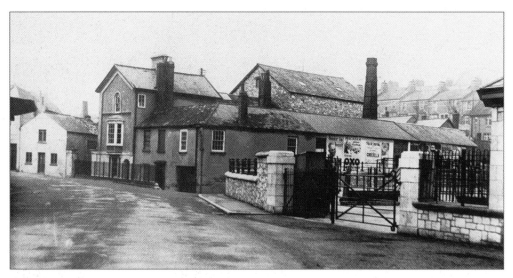

The only reference we still have to Schirebourne Newton is in the name of Sherborne Road, on the corner of which stood Stockman's Mill. This was removed in 1938 to make room for the corn exchange and the new cattle market gates. In this picture we just see the gap in Sherborne Road which still exists between the entrances to the two livestock markets, and leads to the crossing in Halcyon Road and the pathway to Fisher Road.

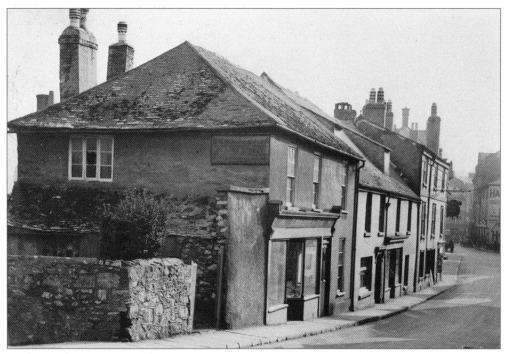

Until 1938 this was the scene looking down Highweek Street from the crossroads of Halcyon Road and Bradley Lane. When the alternative entrance to the cattle market was constructed some of these buildings had to be removed, and the row now ends with the Swan public house – whose sign can be seen protruding from the wall. Harvey's clothing store can just be seen in the distance, opposite the library.

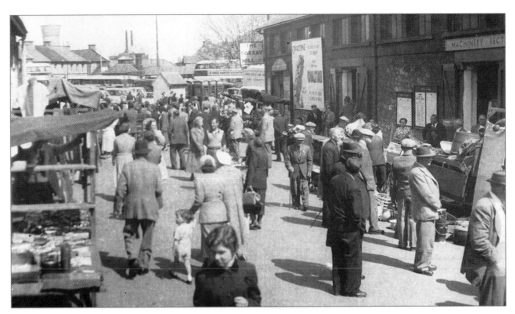

This scene attracted both tourists and locals to Newton Abbot market before the development of the precinct in the 1970s. The temporary open stalls in the street, with traders shouting their wares to draw customers, was a source of entertainment which many visitors considered a 'must' on their itinerary. Perhaps one of the best remembered traders was Mark from Brixham, who could 'work' an audience like an artiste; few would leave his sales point beside the Alexandra Hall without a broad smile on their face. He eventually felt obliged to retire after being mugged, a sad reflection on modern times.

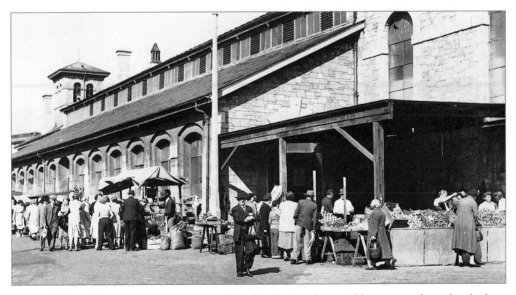

Many of the stalls were semi-permanent, like this fruit and vegetable one run by a family from Kingsteignton. This picture from the 1960s shows just how popular the stalls were, with many locals doing their regular weekly shopping there. Many stalls specialised in one particular product. For example, the boiled sweet stall just inside the entrance to the pannier market, whose products had a unique flavour, will be remembered by many.

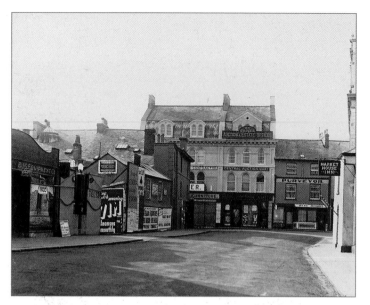

For a number of years this area, known as Foss's Corner, was one of the main bottlenecks for traffic coming from the tower on the left, up through Bank Street to Highweek Street – so much so that at the beginning of the twentieth century the council assumed direct responsibility for the site. The situation was relieved, although not intentionally, in the 1940s, when a fire in the garage on the left meant that the buildings had to be demolished. The buildings on the right (Market House Inn and the shops facing Bank Street) still remain, although there have been many changes of occupancy.

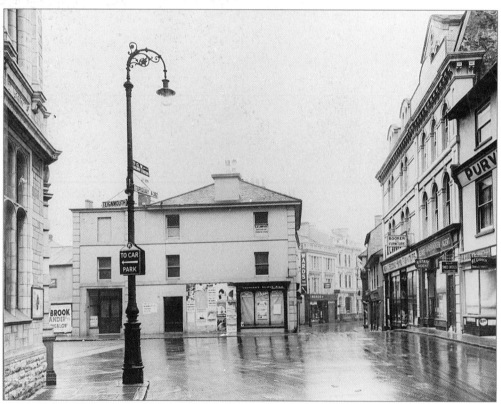

Looking down Bank Street from Foss's Corner, with the corner of the library and technical school on the left, 1940s. Notice the decorated lampstand. Next door to the butcher's on the right was Booker's Auctioneers and Estate Agents, while further down the road many of the shops on the right now form part of Ridgway's shoe store, another family firm which has operated in Newton Abbot for generations.

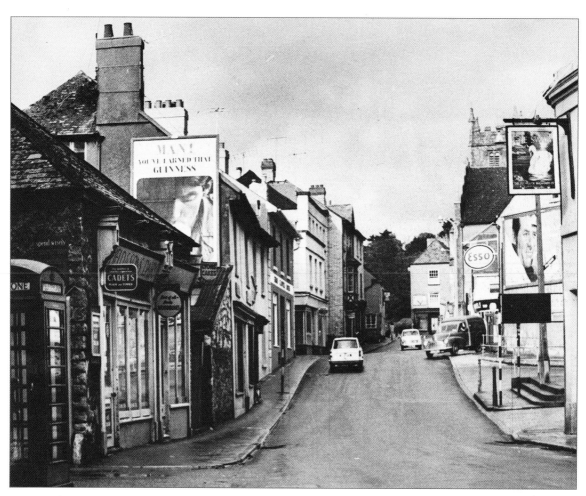

Many clues help us to date this picture to the 1960s, including the style of the cars and the existence of television aerials. Next to Field's Dairy, on the left, the dilapidated property with the corrugated roof was the old Priests' House, once occupied by the clergy who officiated at St Mary's. When this building was demolished it was agreed that the stones from the front elevation should be numbered and stored, to be rebuilt again at a later date as a monument. Sadly, though, this has never happened, as in the early 1990s the council was shocked and embarrassed to discover that many of the stones had been used in the construction of a culvert. Among other shops along the street were Leonard Coombe's, saddlers, Joyce's wool shop and Gerald Glanville's on the corner of Bradley Lane. Shops which had already been demolished included the Black Cat, Wills' butchers, Curwood's and Thompkin's grocery store, which still retained its cobbled pavement. On the far side of Bradley Lane, next to Brookhill's scattered homes for boys, were two more shopfronts, while next door was an alleyway leading to a row of cottages appropriately named Shapley's Court, because it was adjacent to Shapley's store. The shops that used to be above that were Martin's the newsagent, Barton's cake shop and the Seven Stars public house.

Smart flats now form an impressive entrance to the town, built on this site in Highweek Street where buildings awaited demolition in the mid-1970s. Adjacent to the two empty shops on the junction of Bradley Lane, not included in this photo from the Tony Paddon collection, was the Georgian house, seen here, which was one of the scattered homes housing children who were in difficult circumstances.

Wain Lane played a major part in the alterations to Newton Abbot in the early 1980s. This quiet country lane has now been incorporated into a major bypass, with traffic in constant flow from Ashburton Road to the roundabout at the top of Old Exeter Road. The girls' secondary school on the right is now part of the vast comprehensive complex which united all the town's senior schools in the 1970s.

Many Newtonians had a love–hate memory of the various courts which were an outstanding feature of the town. A stroll around the streets shows many relics of where they existed. Near St Leonard's Tower, beside Ernie Braund's butcher's shop, there is a small entranceway with the legend 'No. 1 Court' engraved into the lintel above the porchway. Between 52 and 54 East Street a plaque above the doorway marks the entrance to No. 11 Court, while at the junction of King Street and East Street a plaque identifying No. 9 Court can be seen. This is a picture of Shapley's Court in 1962.

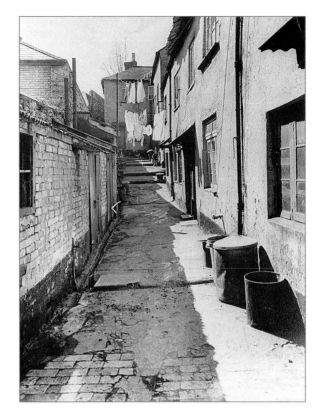

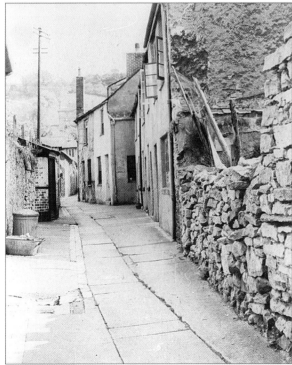

Courts like these were rows of two-up and two-down cottages with outside sanitation, in which whole families of Newtonians were reared. Most were demolished in the slum clearance of the mid-1950s. Here we see No. 5 Court in 1936.

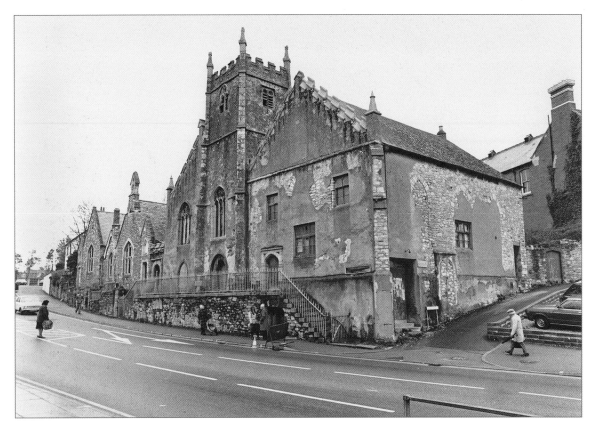

St Mary's Church in Highweek Street is one of the oldest buildings in Newton Abbot, standing sentinel – guarding the inhabitants and forming an impressive entrance to the town. Many generations have had a fondness for the building, and when it was replaced by Abbotsbury Church in 1906 there was much lobbying for its preservation. Since that time, together with the hall and the adjoining Victorian schoolrooms, the church has had a chequered history, serving as substitute schoolrooms, a dance-hall and a part-time theatre. In 1960 some work was carried out by the Young Communicants Guild, but by the 1980s the signs of neglect made the church an eyesore. As can be seen in this picture, taken in 1984, the road improvements merely emphasised the obvious dilapidation and it was apparent that a considerable sum would have to be invested if the church was going to be restored to its former glory. Fortunately a compromise was reached: the interior was converted into flats, but the façade was kept intact.

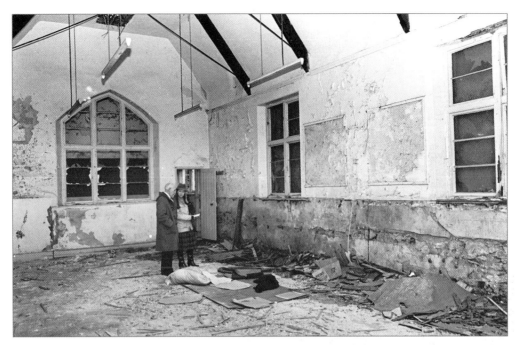

As bad as the outside of St Mary's looked, the interior was even more disgusting. This was also true of the adjoining schoolrooms, which were endowed by Miss Eliza Fagan in 1863 and opened in 1879. Although the building had been vacant for a considerable while, it had been used by Highweek Primary School as an overflow for the influx of evacuees during the war years. In this picture, taken in 1984, we see Bert Simcox, the caretaker, discussing the fate of the building with a journalist from the *Mid-Devon Advertiser*.

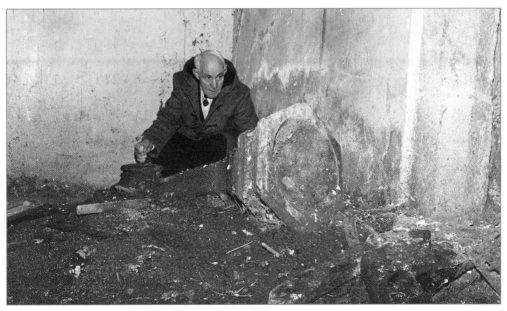

Bert Simcox reflects on what was likely to happen to the church's granite font, which lay in this ignoble state among all the debris and pigeon droppings.

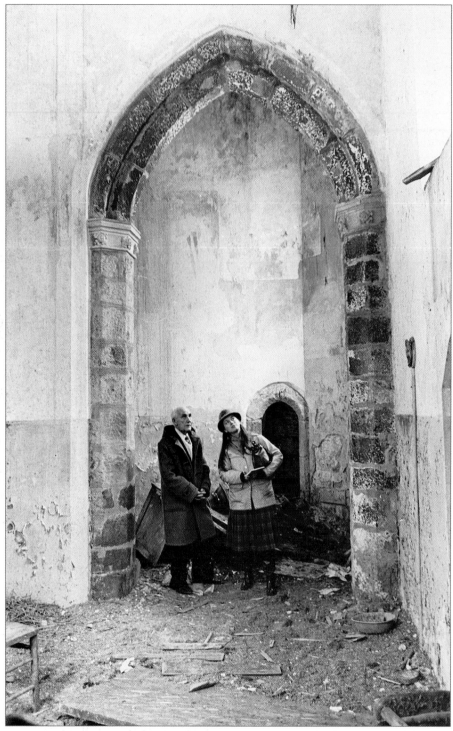

Even among the graffiti and vandalism of the twentieth century this imposing gothic arch proudly portrays the love, care and skill applied by the builders and restorers of the fourteenth century, providing us with a glimpse of the church's former splendour.

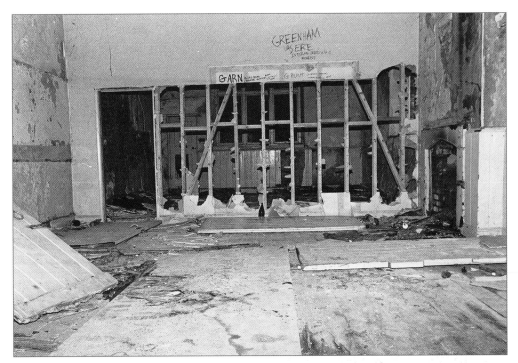

This graffiti reflects the lack of appreciation of the past which is all too often shown by some members of society today. On occasions, though, even those who claimed to have appreciated the building's grandeur have been equally guilty: in 1826, in an attempt to improve the church's appearance, a beautiful arcade was destroyed and four arches were removed, with three unsightly galleries being installed in their place.

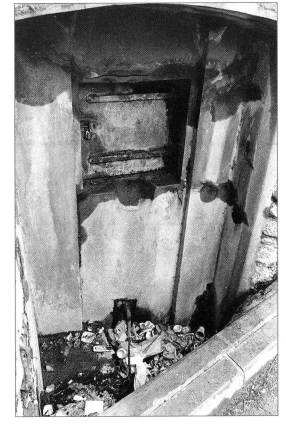

The well at the foot of the tower of St Mary's, sadly in a filthy condition. Until the 1960s stone steps led down to a delightful cobbled floor. The spring of water feeding into the well was claimed to be so pure that sometimes infants were baptised here. Whether this is true, it is a fact that within living memory young Newtonians have cupped their hands under the pipe to drink its sweet water. Since Gilbert's almshouses in nearby Exeter Road were once lazar houses, it could be that the lepers might have used this well as a bathing place, similar to the way Leechwell in Totnes was used.

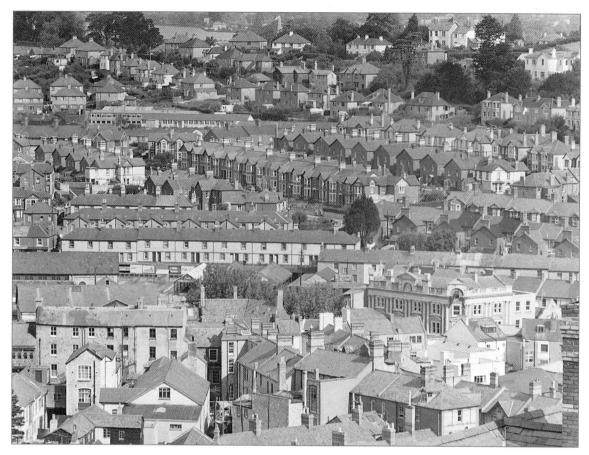

The picture above and those opposite date from the 1950s and illustrate the many changes that have occurred around the market square, not least the demolition of many Victorian buildings. They were replaced by the market precinct and the multi-storey car park. Lloyds Bank, with its famous drum clock, is the most prominent feature in the foreground. In the centre of this picture are the tops of the magnificent plane trees which bordered the market square: the square itself is obscured between the buildings. Even so, parts of the sheep and pig market can be seen, as can the roof of the pannier market. Some of the more obvious changes are the replacement of the grammar school canteen with the Daphne Colman Centre, and the row of houses behind the bank which formed the lower part of Halcyon Road has gone.

Opposite, below: This picture was taken from the spire on the Congregational church in 1987, and helps us to appreciate further what changes have occurred – for example a car park occupies the site of the cricket field. Since this picture was taken the Cricketfield Surgery has been built on the corner of Kingsteignton Road, and the bus maintenance building on the other corner has been demolished.

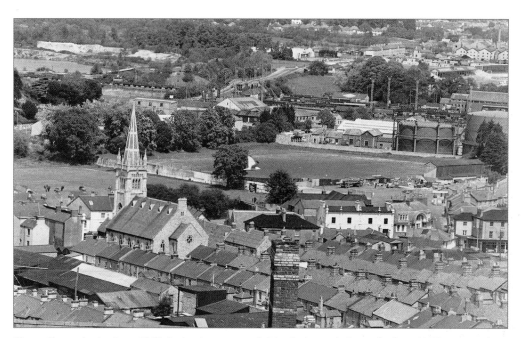

The gull caught in the mid-flight in the centre of this photograph from the late 1950s is not alone in enjoying this bird's-eye view of the town. The Congregational church in the foreground, built in the 1880s, stands out proudly from the cluster of houses in Fairfield Terrace and Prospect Terrace. The area in front of the church was the recreation ground and cricket field. There is a good view of the first floor of the Imperial cinema in the right middle distance. By noticing such things as the scarcity of traffic along Kingsteignton Road and the existence of the garage on the site of the present Tesco store we can begin to see just how much the town has changed.

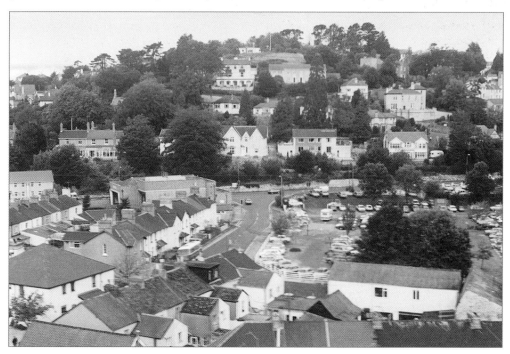

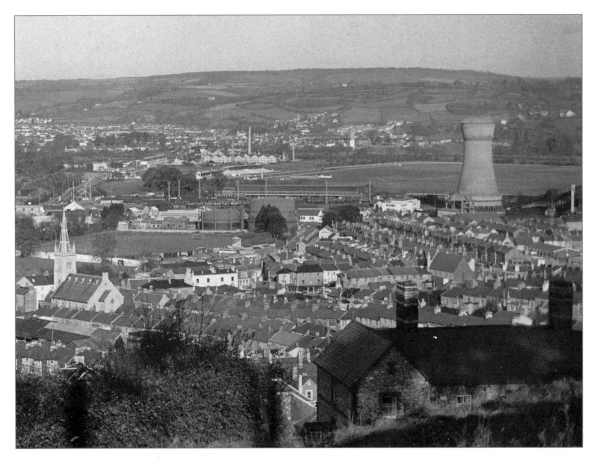

This panoramic view of the lower end of town in the 1960s features three of Newton's outstanding landmarks, two of which have now been demolished. The Congregational church with its spire remains, although it now serves as offices for Woolacombe Watts solicitors. However, the power station (with its cooling tower) and the gasometers have long since gone. Other points of interest include the minimal amount of traffic on the Kingsteignton Road, the fact that Hexter Humpherson Brickworks can still be seen, and the steam rising from the cooling tower, indicating that the power station was still functioning: these all help to date the photograph. In the centre of the picture the front of the Imperial cinema can be identified, while in the background we can see that much of Kingsteignton still awaited development.

Opposite, below: A view of Decoy in the late 1980s shows how well the site of the Devon and Courtenay Clay Pits on the right has been converted into one of the town's more attractive recreation areas. The lake is home for many varieties of wildlife and visitors can also try their hand at canoeing or wind surfing, while others enjoy rambling along the nature trails through the surrounding woods. The area to the left serves as football pitches and playing fields, while a children's paddling pool is near the entrance to the lake.

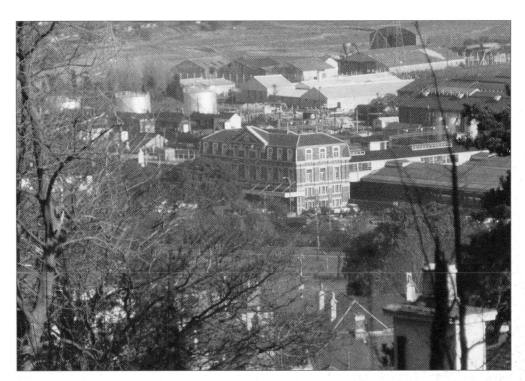

From the lower end of the town we have views of the railway station as it looked in the 1950s and '60s. Originally there were two stations in Newton Abbot, and the platform for the Moretonhampstead branch line still exists to the left of the station. The railway arrived here in 1846 but the station was rebuilt in 1926. After a year experiments were carried out with an atmospheric system, but this failed and the line reverted to steam. Newton was a main terminus for the Great Western Railway and to the rear, in Forde Road, engine sheds catered for forty engines. There was also a large carriage and wagon repair works. Also behind the station there are oil storage tanks in Forde Road; these have long since been dismantled. Behind them is Hill, Palmer & Edwards Bakery, the beginning of what is now a very substantial industrial estate.

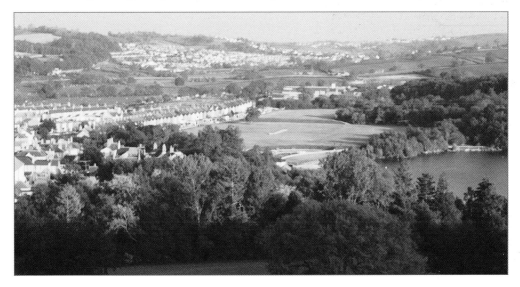

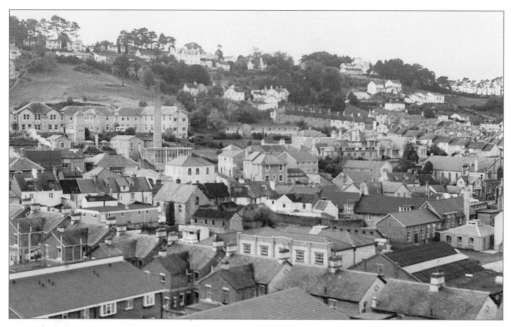

Wolborough Hill, 1987. Most views taken of the town look out the other way. Outstanding landmarks to note include the hospital complex and, in the left middle distance, the imposing structure of the workhouse, built in 1839 at a cost of about £10,000 – which was more than double the original estimate of £4,673. In 1842 the number of unfortunate inmates, some of whom were labelled as 'imbeciles', was 285. This figure had risen to 370 or 380 by 1904. The building itself held sad memories for many Newtonians, who were pleased when it was converted into part of the hospital complex after the Second World War. The huge Victorian rectangular building in the centre of the picture was the Co-op bakery in King Street. It is interesting to realise that even since this picture was taken many more houses have been constructed on the hill.

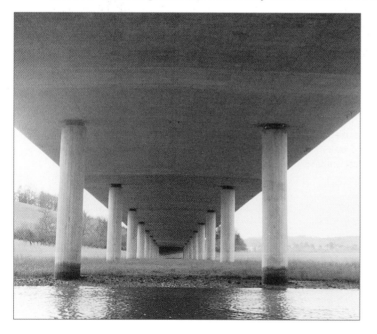

One of the most dramatic changes occurred in 1975 when the dual-carriageway between Exeter and Newton Abbot was constructed as an extension to the M5 motorway. It is frightening to imagine how bad the traffic would be today if this bypass had not been built. This unusual view from beneath the roadway shows some of the difficulties which the engineers encountered as they crossed the River Teign, the Marshes and Hackney Canal. On several occasions the piles were lost in the mud before the foundations were successful laid.

2

Streets & Shops

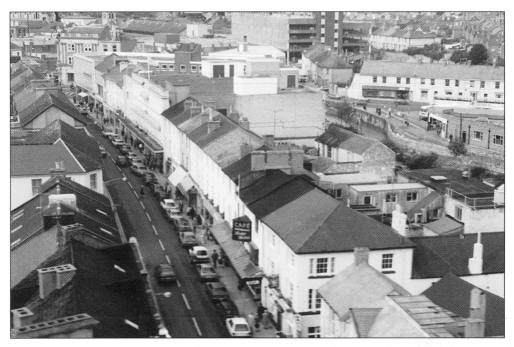

The top end of Queen Street, 1987. Even in the relatively short time since this picture was taken there have been many changes. On the right of the street Madge Mellors is no longer a restaurant, SWEB no longer exists as it did here in the centre of the picture, and the Co-op store toward the end of the street has now been divided up and is occupied by small shops. In the middle distance on the right is the bus station, which is no longer in the town, while the houses opposite on the Kingsteignton Road have been replaced by a car park. As for the multi-storey car park, it has since been necessary to encase this with safety railings.

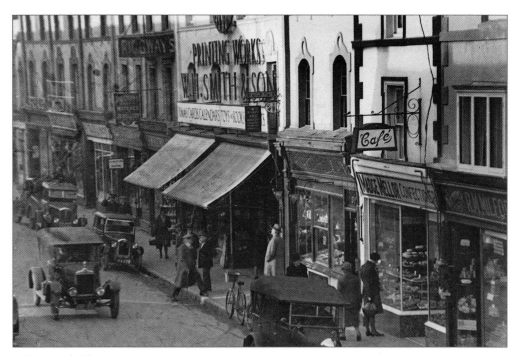

There are not likely to be too many Newtonians who remember this scene from 1928, but quite a few will be able to recall when the town looked something like this. W.H. Smith operated from this site until the 1950s, when it moved to Courtenay Street. Many might also remember the library at the far end of the shop. However, it might surprise some to see that Madge Mellors, which later developed into quite an impressive restaurant, started in such a small way. Ridgway's is a company which is remembered more for its premises in Bank Street and the little boot and shoe repair shop in Wolborough Street than as a jeweller and watch repairer, as advertised here.

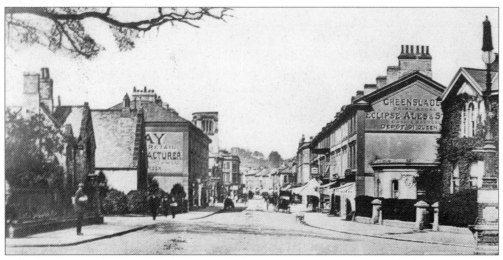

In the distance on the left there is no spire on the Congregational church, thereby establishing the date of this photograph as before 1921. This date is verified by noticing the bough of the tree in the left foreground, which is most likely part of the old oak tree which was felled and replaced by the war memorial in 1922.

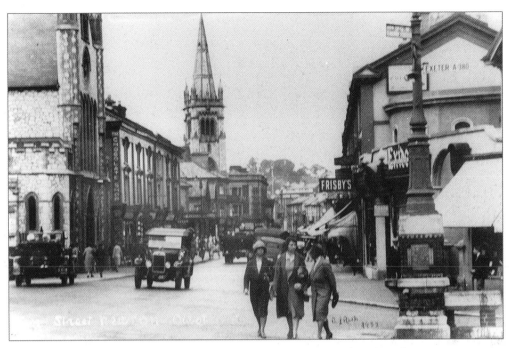

There are many features in this picture which show it to be a later date than the previous one. Not only does the style of dress identify it as being from the 1930s, but we can now see the spire on the Congregational church and alterations have also been made to the front of St Joseph's Church. In both pictures the lampstand is seen in the centre of The Avenue, with its trough at which horses quenched their thirst when they were hauling clay from the Devon and Courtenay Claypit at Decoy.

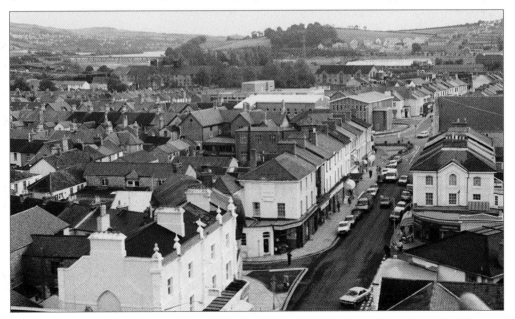

Looking down Queen Street towards the station, 1987. One-way traffic systems had become necessary long before this date. The gas works and the power station have already been demolished; since the picture was taken flats have been erected in their place.

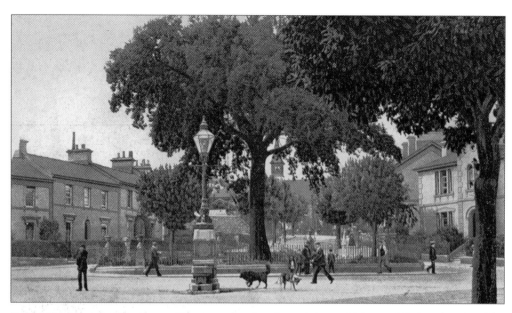

One of the more popular views of Newton, showing the oak tree which was felled and replaced by the war memorial. This monument, known as the 'Spirit of Freedom', was erected in 1922, with a backdrop being added after the Second World War. The tree was cut up and pieces were sold to help meet the cost of the memorial.

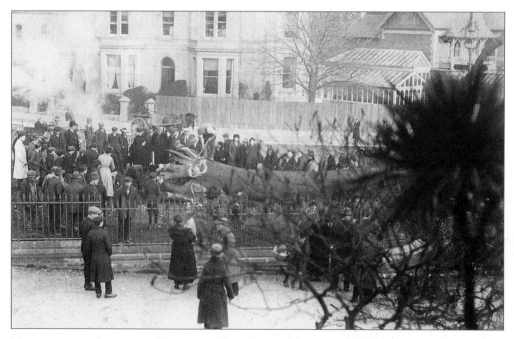

Many pictures of Newton Abbot show the oak tree standing proudly on the site of the war memorial before 1922. However, this rather rare picture shows the mighty oak after it had been felled, with many bystanders possibly reflecting that things would never be the same again. Many of the small blocks into which the tree was cut were used as door-stops and can still be found in many homes today.

Workmen installing Courtenay Pollock's
'Spirit of Freedom' on its plinth at the war
memorial, 1922. The present backdrop,
containing the names of those who lost their
lives in the Second World War, was added at a
memorial service on 21 June 1949. This was
attended by local dignitaries and various
branches of the armed forces and local
organisations.

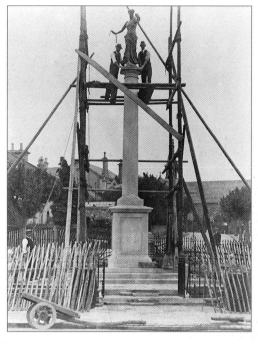

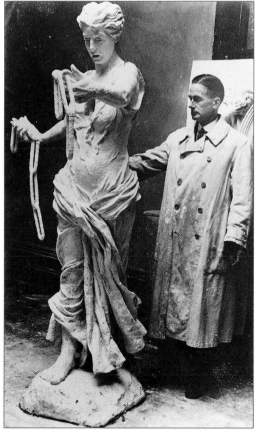

Courtenay Pollock in his studio, admiring his
finished sculpture of 'Spirit of Freedom'.
There was a great deal of controversy over its
suitability before it was finally accepted by the
town's representatives.

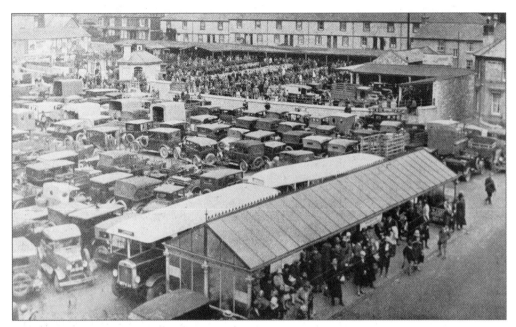

The market square was the venue for many different events, and this picture shows just how congested it could become. It was obviously popular, drawing crowds from the outlying towns and villages. On market days the square would often be full to capacity with parked cars.

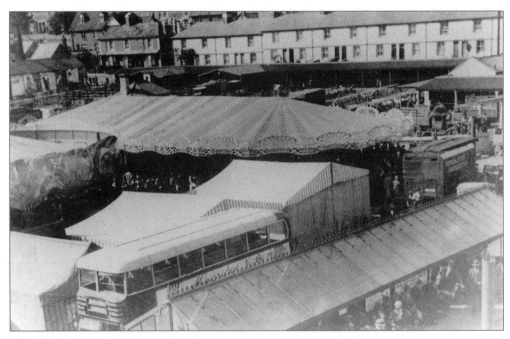

The cheese and onion fair was also held in the market square annually, which always caused problems for the bus depot. By this time double-deckers were operating on many local routes, particularly to Torquay. When the refurbishment of Market Walk took place the bus depot was moved to the corner of Kingsteignton Road, but in 1992 this was demolished and the Inland Revenue and Job Centre building was erected on the site. This picture dates from about 1940.

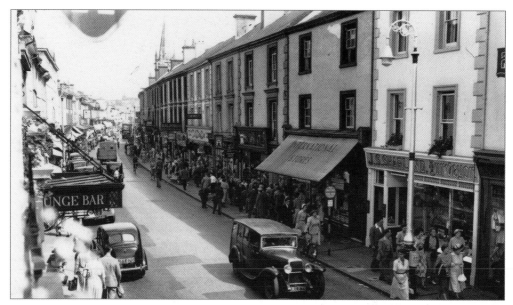

This picture of Queen Street from the 1950s will no doubt evoke feelings of nostalgia in the hearts of many Newtonians, who look back longingly to those days when shopping was an adventure. One could wander freely in and out of the many little shops, and even jaywalk in relative safety, even though the traffic flow was two-way. The sign on the right-hand pavement reads 'No Waiting this Side Today', indicating that parking was allowed on one side at a time. It is interesting to note just how obediently everyone complied, except for the lorry making deliveries in the background.

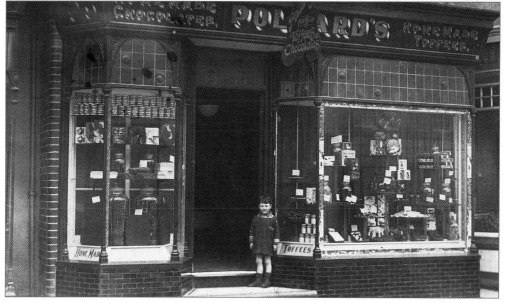

Most Newtonians will remember Pollard's confectionery. For many years the company manufactured its wares at various factories, including premises at Bradley Lane and Brunel Road, and became famous for its homemade chocolate and toffee. In this picture from about 1925 we see (it is thought) Mr Donald Pollard as a boy, standing at the entrance to the family's shop at 112 Queen Street.

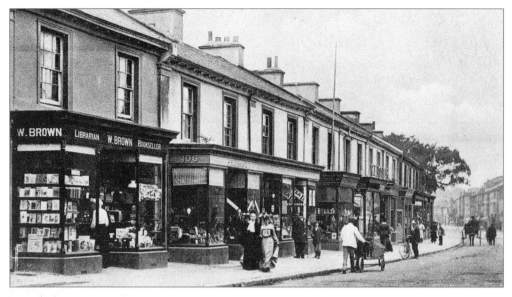

Even more obvious than the absence of traffic in the lower end of Queen Street in this photo of about 1900 is the style of shops. Many of these are now take-away, fast-food premises, which means that this part of the town is usually busier during the evenings. The next sequence of photographs, together with many others in this book, are from the marvellous collection belonging to Mrs Paddon and her son Richard. The late Tony Paddon was an avid collector of postcards, and we can be grateful to him that such a fine pictorial record of the town has been kept.

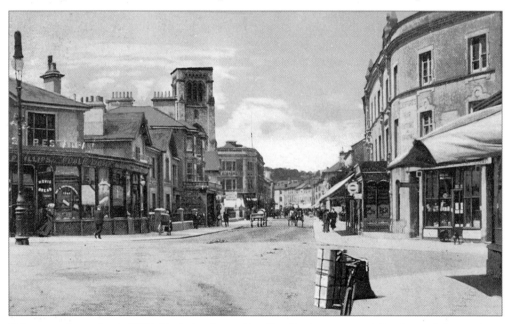

This scene from about 1905 illustrates how attractive the town was at the turn of the century. Of particular note is the fact that there is no spire on the Congregational church tower. Neither is there any sign of the Imperial cinema, which later stood prominently on the corner of Lemon Road on the right. The shop with its window facing at right angles to the road on the right was occupied by the *Mid-Devon Advertiser*.

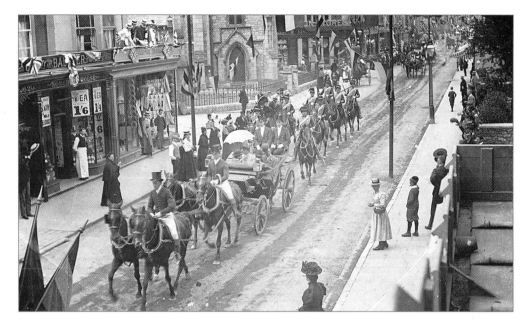

Newton Abbot has witnessed many processions, but not all as spectacular as that of the Duke and Duchess of York in 1899 who were in the county to visit Lord Clifford of Ugbrook. The streets were lined by volunteers including Rifle Artillery and Engineers from surrounding towns, while the Royal 1st Devon Yeomanry formed an escort. About 2,500 children were provided with tea on the recreation ground. Each child was given a bible as a souvenir, and a medal to mark the occasion.

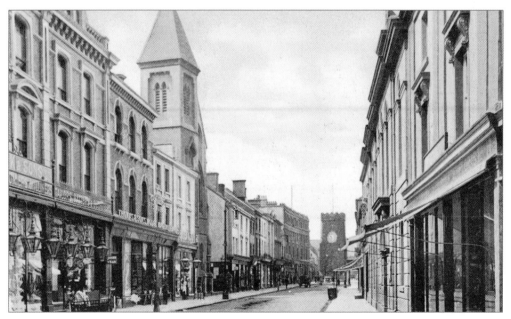

Courtenay Street, early 1900s. The Wesleyan Methodist church is on the left. The spire proved to be dangerous and had to be removed. William Badcock and Sons was the large drapery on the left, while the town hall was on the opposite side of the road. Most of these buildings have been either altered or demolished, but St Leonard's Tower at the end of the street continues to stand guard over the town.

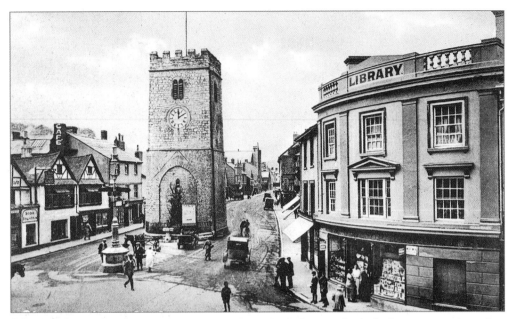

Since the year 1220 St Leonard's Tower has been the hub around which the town revolves. Cars had begun to put in an appearance by the time this photograph was taken in about 1920. Until 1836 the space in front of the tower was occupied by St Leonard's Church, which was demolished in 1836 and rebuilt further along Wolborough Street. The octagonal stone at the foot of the tower, detailing the arrival of William of Orange, who became King William III, in 1688, has more recently been moved nearer to the tower.

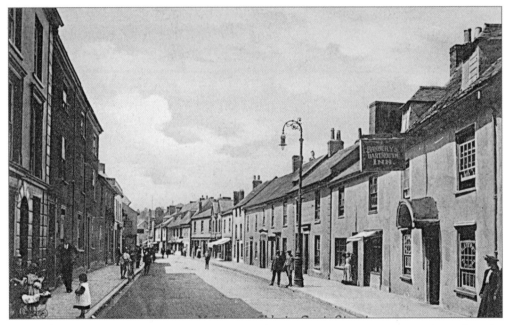

Although East Street existed before Queen Street and Courtenay Street, it was relegated to the status of a secondary road through the town. On the right is the Dartmouth Inn. When this picture was taken, before the First World War, the Newfoundland Inn was at the bottom right of the street.

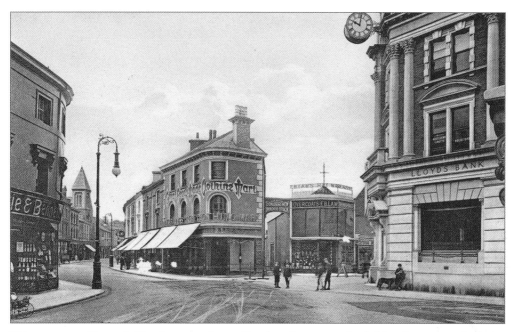

This was part of Laws & Warehams outfitters. The two shops were divided by The Grove, which ran behind the shops in Courtenay Street. Next to Laws & Warehams was Renwick's Travel, and further along was the Devon & Exeter Savings Bank.

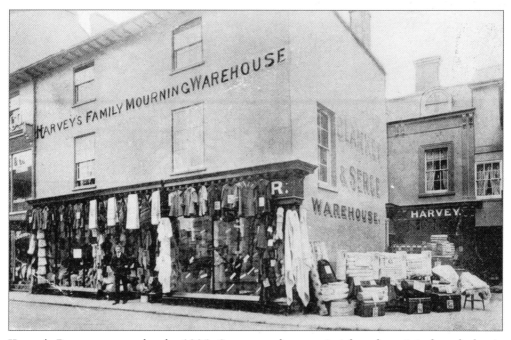

Harvey's Drapery one-week sale, 1905. One can only guess just how long it took each day to display the goods, and one can imagine what modern by-laws would have to say about hijacking the pavement in this way.

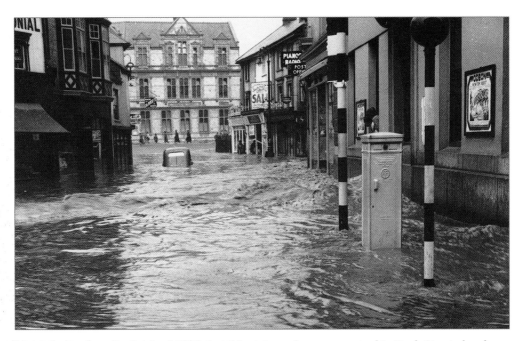

Many photos show the floods of 1938, but this picture of a car marooned in Bank Street also shows the ferocity and depth of the water as debris is carried down through the street.

The derelict Odeon cinema can be seen in the background of this picture of Union Bridge from the 1960s. Another bridge once spanned the River Lemon here, taking pedestrians from Back Road to the Odeon car park.

The library and technical school were erected as a joint venture between the town and one of its great benefactors, Mr Passmore Edwards, in 1902. Passmore Edwards' original plan was to donate a hospital in memory of his mother who used to live in the town. However, because Newton Abbot had only recently acquired a new hospital it was agreed that the generous gift should be a library.

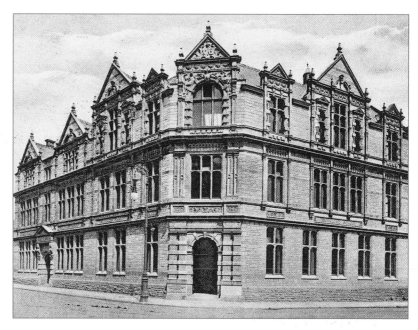

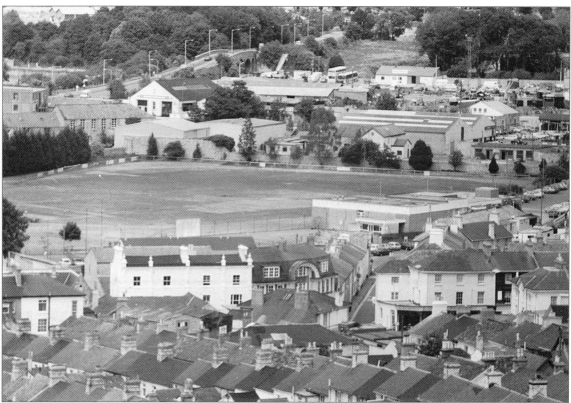

In the centre of this picture is the Newton Abbot Recreational Trust, which caters for the majority of local sports activities, including soccer, tennis and cricket. This photograph, taken in 1990, shows clearly the redevelopment of the Cricketfield/Marsh Road area which occurred in 1970.

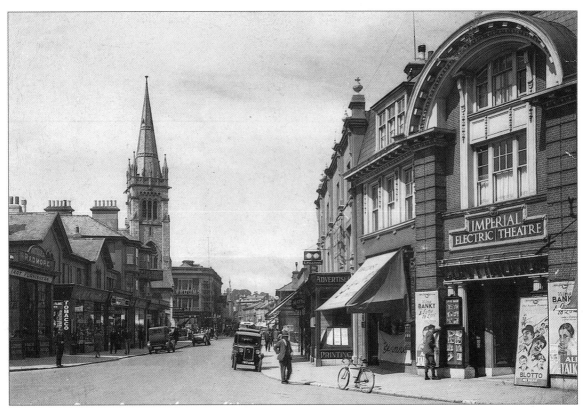

Besides the museum and those individuals with one or two pictures of the town, we can be grateful that there are some 'serious' collectors of postcards and photographs willing to share their treasures with us. Richard Paddon is one such, and another is David Mason of Torquay: the next four pages, together with others elsewhere in this book, contain a selection from Mr Mason's collection. This photo of Queen Street, possibly from the 1930s, presents a wonderful view of the Imperial cinema detailing forthcoming films. Of particular note is the poster advertising the 'all Talkie' film.

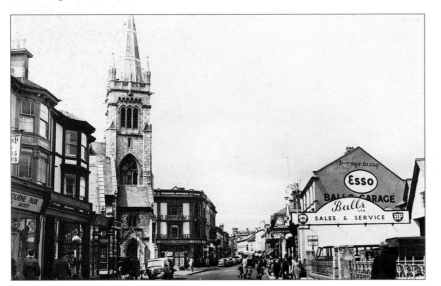

Another picture to stir the memory is this one of Ball's Garage, next to Bearne's School in Queen Street. The site is now occupied by Argos (previously by Gateway's supermarket). It was from here that Potters' buses used to operate, taking generations of townspeople up to the moorland towns and villages. The petrol pump for retail sales is actually on the pavement, on the garage forecourt.

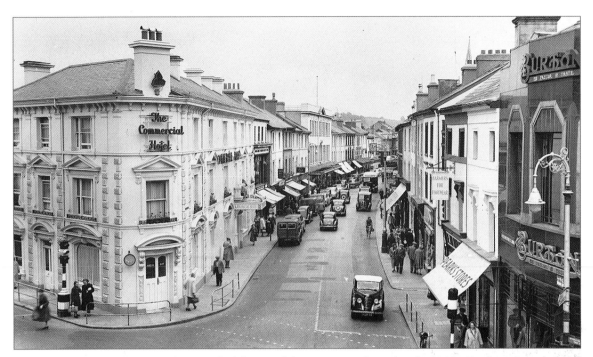

Looking down Queen Street, with a wonderful view of the Commercial Hotel early 1960s. Further along the road is the Co-operative store, while a name from the past is Peark's Stores on the right. High up on the roofline of Burton's can be seen the slogan 'Tailor of Taste'. At this time it was still possible for the street to deal adequately with two-way traffic.

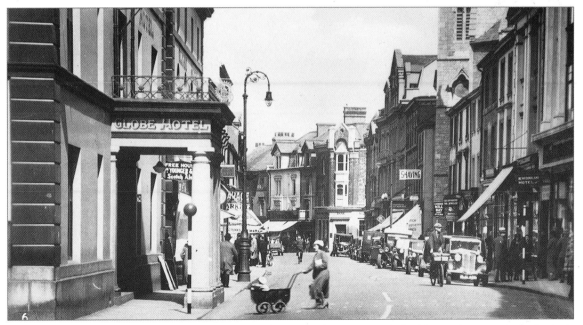

Courtenay Street, late 1930s. The pram being pushed across the street, and the 'shaving' sign over the barber's shop, next to the Methodist chapel, are both reminders of past days. The ornate lamp also reflects the style of the time.

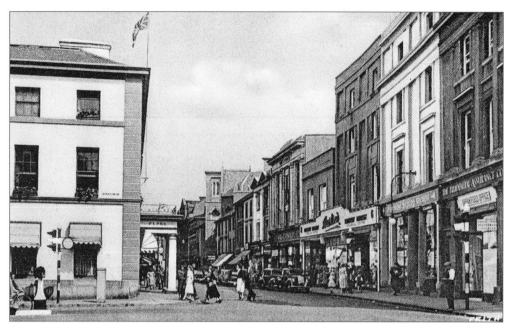

The temporary shop sign 'area food office' on the Prudential Assurance Company on the right indicates that this picture possibly dates from just after the Second World War. Stiling's chemist with its granite steps leading up to the shop entrance is a further memory for Newtonians, and another famous name is Austin's, which has greatly expanded.

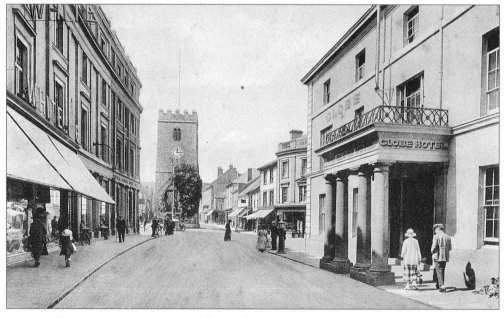

St Leonard's Tower, *c.* 1920: the postal date of this card is 1924. It is interesting that the varying styles of women's clothes in the picture could place it anywhere within a thirty-year period. At this time Timothy White's was opposite the Globe Hotel.

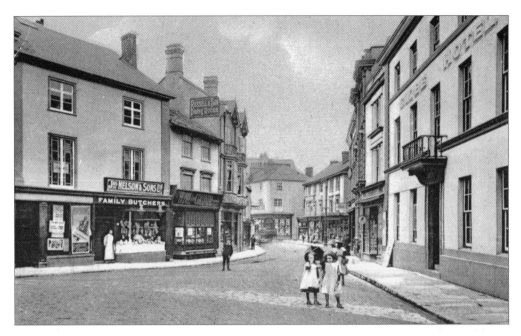

We can appreciate the effort that was put in by the photographer before this picture was taken. All the people are stationary, including the man turning the corner. This implies that the photographer would have had to go into the butcher's to persuade the shopkeeper to stand in his doorway. Many will remember the Home & Colonial stores on the left, with the aroma from the coffee grinder permeating the air.

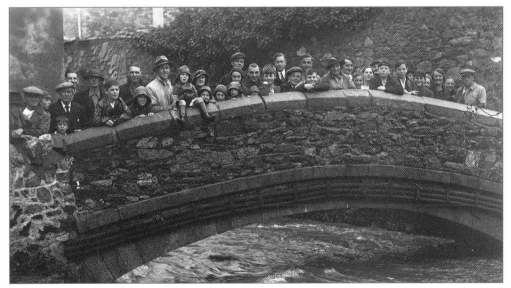

The youngsters in this group on the bridge in Back Lane, watching the 1938 floods are now in their mid-seventies, and many are themselves now grandparents. This appears to be Union Bridge, which was built in 1822 and united the two towns of Newton Abbot and Newton Bushel. The level of water may possibly indicate that the picture was taken after the flooding, which caused quite a lot of devastation. It is noteworthy that after the 1979 floods the water level dropped suddenly; the next day it was hard to accept the extent of the flooding only a day before.

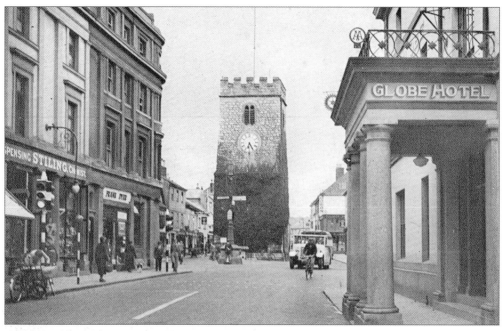

The character of Newton Abbot has changed dramatically now that the pedestrianization of Courtenay Street has taken place, but this view of the town from the 1950s is one which many will remember with fondness. On the left is Stiling's chemist, and to the right is the impressive Globe Hotel – a coaching house when horse-drawn vehicles travelled through the town.

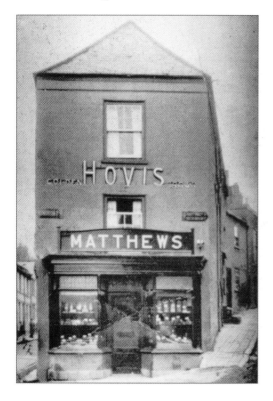

Robert and Edith Matthews came to Newton Abbot in 1927 or 1928 and opened their bakery in the little shop at the junction of Highweek Street, Highweek Road and Exeter Road. The bakery had this small shop at the front of the premises but the living accommodation was very modest. An oven was installed in the living room but eventually the whole first floor was devoted to the bakery. Besides home baking, the shop sold sweets and biscuits, all from large tins or jars. Specialities of the shop included sponge fairy cakes, meat pasties and fresh eggs.

In 1938 or 1939 Matthews' Bakery moved from Highweek Street to 64 Queen Street, where it continued to trade as one of the more established firms of the town until 1998. This picture, taken during Newton Abbot Shopping Week in September 1956, demonstrates the efforts made to support local trade.

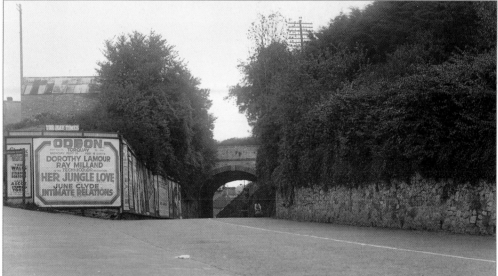

The bridge over the Torquay–Newton Abbot road at Kingskerswell, 1950s. This portrays a scene which few can remember and everyone yearns for. The arch was so narrow that only one line of traffic could pass at a time. Even though the road was widened in 1964 it soon became choked, and ever since the local people have agitated for a bypass which was promised when the dual-carriageway was constructed between Exeter and Penn Inn. Of particular note is the placard on the wall advertising forthcoming films.

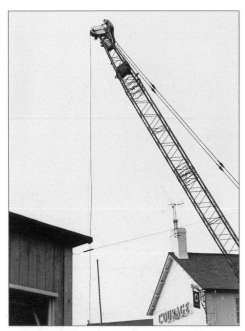

This crane has very little significance until we link it with the picture below. We might wonder what it is that holds the group of people spellbound, but we get a very good clue from identifying the sign on the public house and recognising it as the Lord Nelson in Kingskerswell.

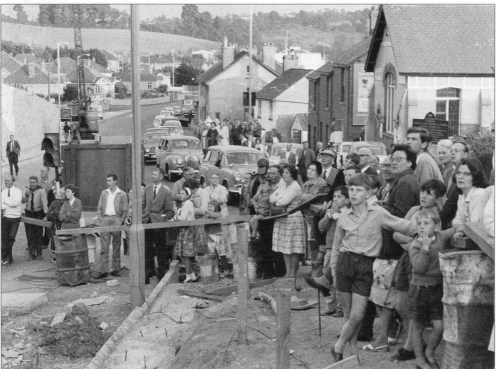

This picture, taken from the junction of Water Lane and Newton Road at Kingskerswell, can only mean one thing – the removal of the bottleneck at the arch when the road was widened on 4 July 1964. In spite of these efforts the traffic problem still exists, and we constantly hear pleas for a Kingskerswell bypass – which seems as far from reality in the year 2000 as it ever was. The crane can be seen in the background on the left.

3

Education, Religion, Welfare

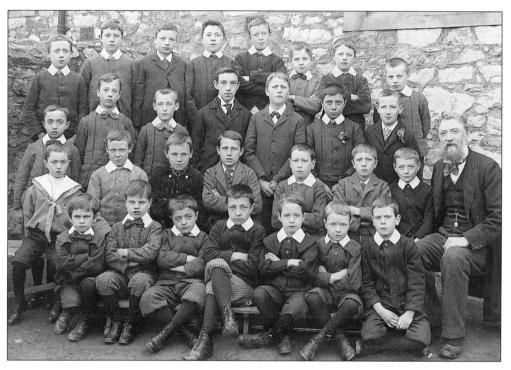

According to the Charity Commissioners Report, dated 1822–1909, as early as 14 February 1788 the need for educating the poor was recognised. In that year a trust was founded by Hannah Maria Bearne for establishing a school for teaching reading, writing and arithmetic to the poor children of Wolborough and Highweek. In 1821 a sum of £60 was allocated annually for the schoolmaster to teach reading, writing and arithmetic to fifty boys and girls and £26 to a schoolmistress for teaching forty children to read only. The master was paid £1 per annum for each scholar and the mistress 3*d* per week for each child. The children stayed at the school for four years and bibles were provided for each from the charity. On 14 March 1859 a piece of land, part of Clam Field, was purchased for £22 and a school was erected on its present site at a cost of £720; it was extended in 1821. Here we see the headmaster Mr Fawkes with boys from the school in the early 1900s.

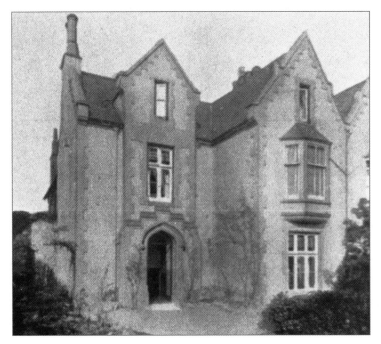

The house named Woodstock in Courtenay Park was the original grammar school. This was founded at the behest of the Revd Mr Tudor, who called a meeting on 27 October 1883, at which the Earl of Devon presided, to consider establishing such a school for middle-class inhabitants of the town. Mr J.W. Crawley MA of St John's College, Cambridge, became the first master of Newton Abbot Boys' School, as it was named. Mr J.R. Woodhams BA became the headmaster in 1892, and in October of that year the school was named Newton Abbot Grammar School. In 1915 the secondary school in Exeter Road became the grammar school, and this existed until the 1970s when the senior schools in the town became comprehensives.

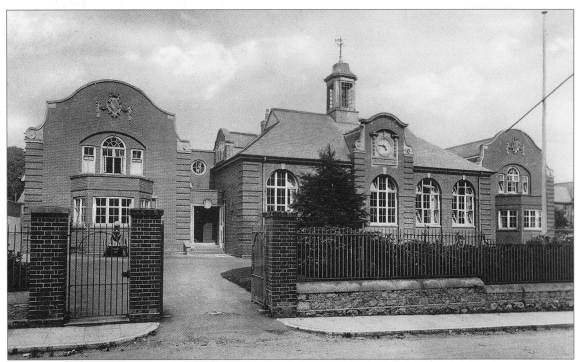

Until 1915 this fine school building in Old Exeter Road housed the secondary school, but from that date it became the grammar school. Although it functioned as one school the sexes were completely segregated, with the girls using this entrance and the left part of the building, while boys occupied the section on the right. Even the playing fields were separated, with the girls using the field to the rear of the school and the boys using the one in front on the opposite side of the road.

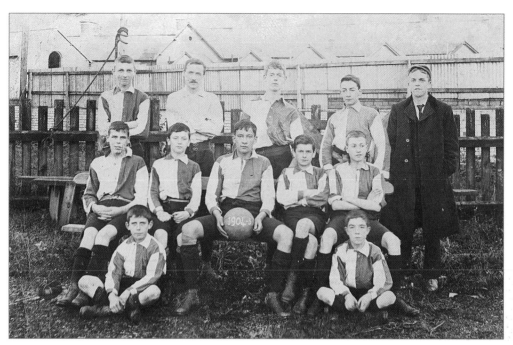

By about 1904 Newton Abbot Grammar School was already playing its part in local sports. As early as 1898 we have reports of cricket matches being played against other schools, and this picture from those early days shows the members of the soccer team with the referee Mr R.C. Coombe.

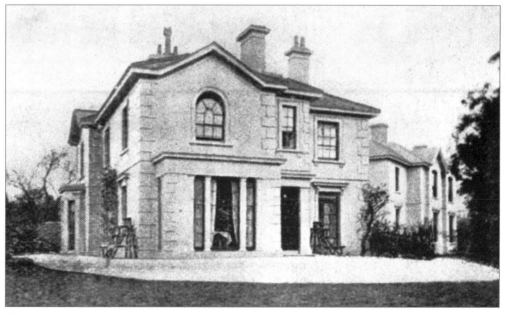

This house in Station Road, until recently housing Messrs Reynolds & Co. and previously the social security offices, was once Newton Abbot High School for Girls. In January 1898 the annual prize-giving for this school was held at the Globe Hotel. At that time Miss E.M. Slaughter LLA was the headmistress.

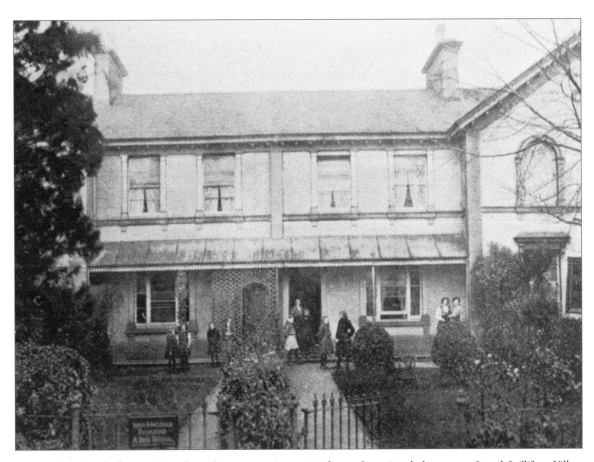

These houses on the corner of Forde Park, just over Station Bridge and previously known as 2 and 3 Clifton Villas, were previously Fordeleigh College. Some of the pupils can be seen in this photograph from the early 1900s, standing outside the building.

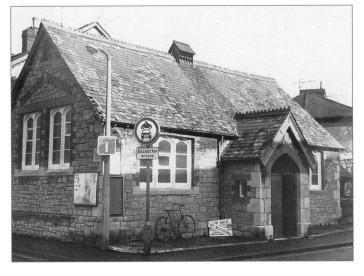

Although this building in Albany Street now belongs to the Co-operative Society and is a chapel of rest, it has served as a Kingdom Hall of Jehovah's Witnesses, and before that it was a Unitarian chapel which was also used by various organisations, including the Church of the Latter Day Saints. Yet it was originally built in 1871 as a school on behalf of Miss Ann Wall, the daughter of the owner of Bradley Manor. Constructed on a site known as Reynell's Marsh, it was presented by deed as a gift on 23 April 1900 to the trustees of Bearne's School, to be disposed of and the monies to be used at their discretion. The proceeds of the sale, £270, were applied towards the cost of improving the sanitary arrangements of Bearne's School.

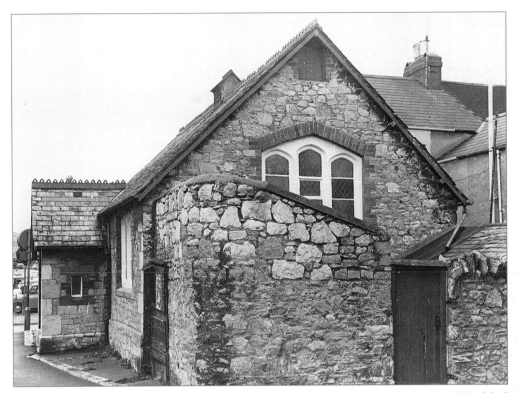

The Unitarian chapel in Albany Street, previously Miss Wall's school. In 1974, after the chapel had been sold by public auction, its roof was replaced, new windows were installed, the rear part of the wall was demolished and rebuilt. The whole interior was gutted and reconstructed.

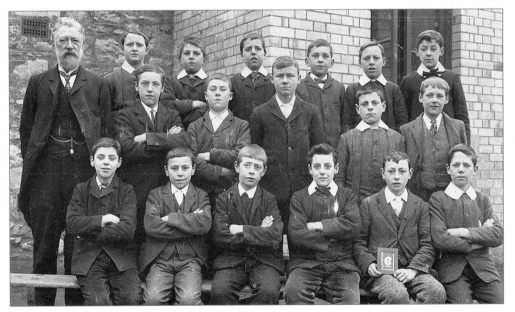

The senior boys of Bearne's British School with their headmaster Mr Fawkes. Mr Fawkes was headmaster from 1881 to 1912.

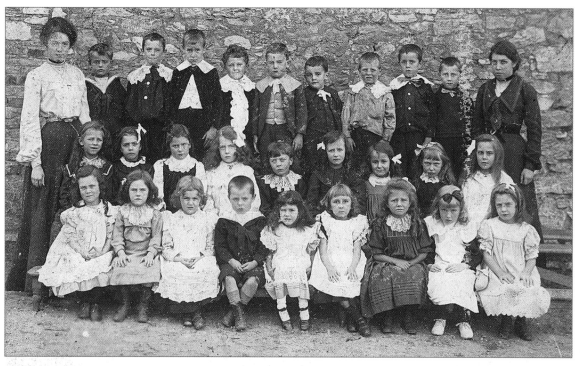

This group of youngsters from Bearne's School in about 1910 were obviously apprehensive of the photographer, Mr Edward Balam of Mutley, Plymouth.

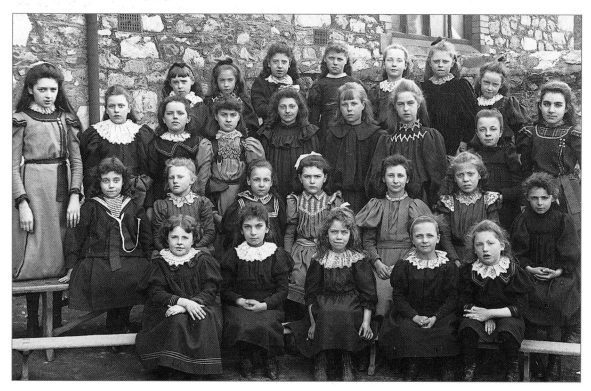

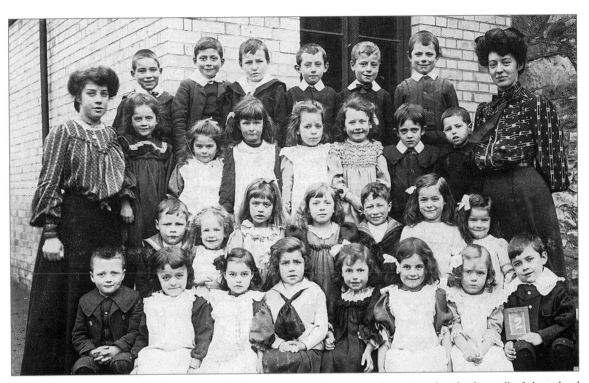

Although the quality of the photographs had improved over the years, the setting beside the wall of the school remained the same. Some of the children also seem a little happier, with some even prepared to smile for the camera.

Opposite, below: No, not girls from St Trinian's, but the pupils of Bearne's British Girls' School posing for photographer Herbert Norris of 18 Queen Street, Newton Abbot. From 1888 to 1907 the headmistress was Miss Little and from 1907 to 1926 Miss Cook (later Mrs Holmes).

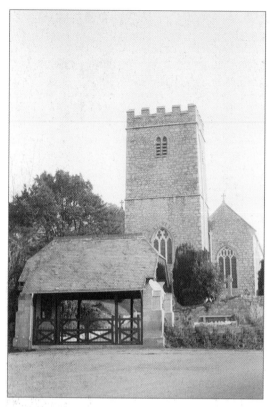

According to Rhodes' history of the town, St Mary's on Wolborough Hill was originally a Roman Catholic sanctuary and the last church in Devonshire in which Mass was celebrated at the time of the Reformation. It houses many interesting relics, including a magnificent effigy of Sir Richard Reynell of Forde and his family. There is also a beautiful brass eagle lectern, which was found buried on Bovey Heath where doubtless it had been hidden during the Civil War. In 1865–6 the church was restored and reseated, and in 1881 an organ chamber and vestry were added. One famous visitor was Charles I, who worshipped here in 1625 when he visited Forde House.

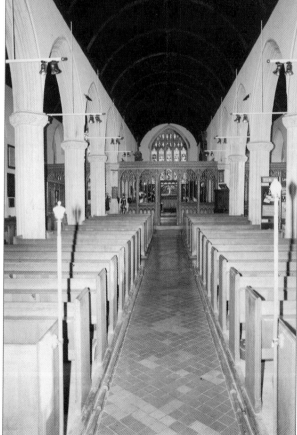

The interior of St Mary's has many outstanding features which make it unique. Among these are its wonderful barrel roof and a rood screen, which contains paintings of apostles and disciples of Christ that are not repeated in any other church in the country.

Along the north wall is a tomb with effigies of Sir Richard Reynell and his family, erected by his wife Lucy a year after Sir Richard's death in 1633 at the age of seventy-one. It also shows her affection for her daughter Jane who died that same year, and her son John who died in infancy. Sir Richard's wife Lucy is seen lying beside him; below lies their daughter Jane and at the base their son John. The epitaphs extol the virtues of Sir Richard and the first word of each line on the plaque above Lucy spells out the name Lucy Reynell. It appears that the figures of Jane and her brother were added to the monument at a later date.

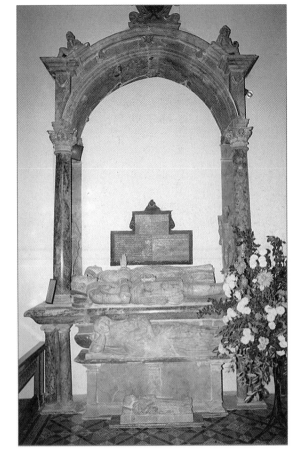

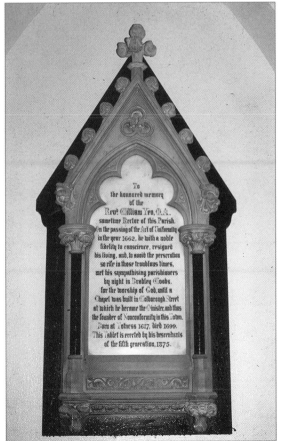

This plaque to the memory of William Yeo now stands in the porch of the lych-gate at Wolborough church. Until 1984, when, owing to falling numbers, the members of the Congregational church joined in worship with the Methodists, it hung in the entrance of their church in Queen Street. Its current site is appropriate, as from 1648 to 1662, when Charles II allowed the Act of Uniformity to evict several uncooperative clergy from their livings, Yeo served as rector here at Wolborough church. After his eviction he and his followers held secret meetings in Puritan's Pit in Bradley Woods.

Puritan's Pit, in the heart of Bradley Woods, is where William Yeo and his supporters held secret meetings between 1662 and 1672. A picture, donated by a descendant of the minister, used to hang in the Congregational church. The subject of the picture was a wedding being performed at the Pit, but it is more likely to have been the result of artistic licence than based on fact. From the late 1940s the members of the Congregational church used to hold an annual pilgrimage to the Pit, where a service was conducted.

It was in 1873 that the members of Salem church purchased the land in Queen Street, an orchard owned by Mr H. Jacobs, at a cost of £175. The first service was held here on Thursday 27 April 1876 in the building which had seating for about 600. Because of falling attendances the sixty members who attended a special meeting in November 1982 reluctantly authorized a committee to seek a buyer for the premises.

When William Yeo was again granted a licence to preach, he and his followers met at Pound chapel, 51 Wolborough Street. Another chapel stood on the other side at no. 68, and in 1843 the two congregations joined, meeting at Salem chapel which had been endowed by Mrs Hannah Maria Bearne on 14 February 1788. Later in the 1870s the new Congregational church was built in Queen Street, and Salem chapel was used as part of a car showroom for Bulpin's Garage, then Wadham Stringer.

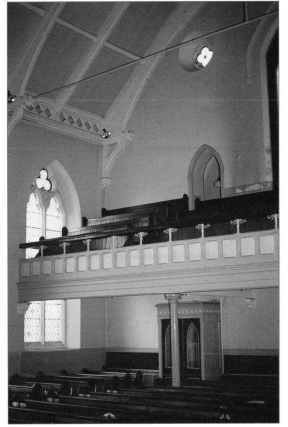

From this picture of the pews in the main sanctuary and the overhead gallery we can see that even though the members were few in number they certainly cared for their church. In March 1936 the church members agreed to redecorate and refurbish the interior, including the installation of central heating. This was in preparation for the celebration of their Diamond Jubilee. A special fund was set up to raise the estimated cost of over £1,000. Celebrations were spread over a period of eight days, and included a service in Puritan's Pit.

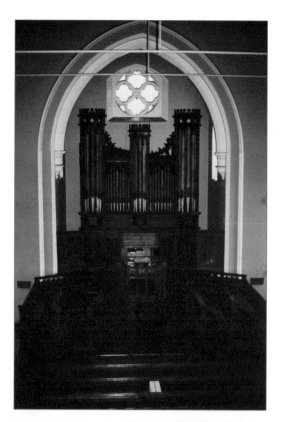

During the refurbishment in 1936 the organ in the Congregational church, which had been installed in 1904 by Hele's of Plymouth at a cost of about £500, was renovated, and its water-operated pump was replaced by an electric fan blower.

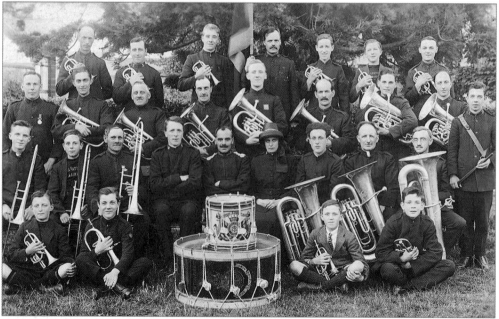

The members of the Salvation Army Silver Band, 1925. The members for that year included Sergeant Major Hasking, Recruiting Sergeant Arnold, Bandmaster H. Brinton, and Bandsmen Hamilton, L. Hasking and Burnett.

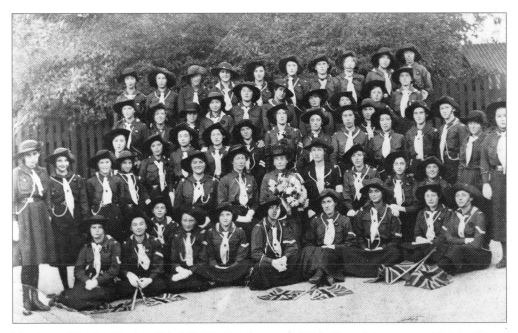

Members of the 1st Newton Abbot Girl Guides Company, 1916. Since this movement had only been formed by Sir Robert Baden Powell and his sister Agnes in May 1910 – three years after the Boy Scouts – the fifty-plus members here appeared to be a formidable force.

Until the Poor Law Amendment Act of 1834 each parish had the responsibility to care for its own poor. Highweek had its own establishment, and the Poor House for Newton Abbot existed in East Street between what became the Dartmouth Inn and the Devon Arms (now Strikers). In this latter building hung a large mural depicting the growth of the town, and the small section reproduced here shows the exploitation of those who found themselves in the unfortunate position of being inmates. In this scene of the oakum picking room (which was later the cellar of the Devon Arms) we see a man picking through the oakum, while behind him is the outline of a young woman who is unravelling the pitch-impregnated knotted rope ends from which the fibre was extracted. Vicious spikes protruded from a board against which the bits of rope were forced and untwined. It is easy to imagine how hands and fingers could be caught on the spikes, and how the torn flesh would fester as it came in contact with the infected rope.

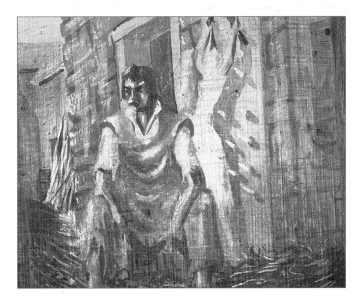

To comply with the Poor Law Amendment Act the Newton Abbot Union was formed in 1836, incorporating thirty-nine of the surrounding towns and parishes. In 1839 the Union workhouse was opened, and in 1842 the recorded number of inmates was 285; however, this number dramatically increased, for by 1900 there were between 350 and 400. The estimated cost of the building had been £4,673, but the final cost was in excess of £9,373. Finances seemed to be the overriding concern, and in 1894 a great scandal arose with regard to the terrible treatment of the inmates. This resulted in many sackings and the number of staff was increased. However, when the Board decided to appoint a chaplain at a salary of £60 there were no applications for the post. In 1896 a contract was made for a new infirmary with the foundation stone being laid by Mrs Scratton, and the new building was opened in 1898 by Lord Clifford. The following year a spacious dining hall was added and over £20,000 was spent on the new building. In spite of such improvements many inhabitants grew up with the dread of ending their days in this horrendous institution.

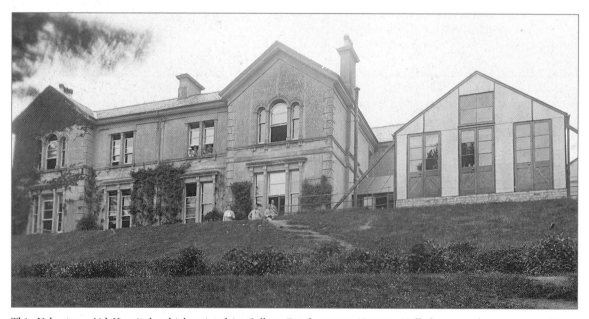

This Voluntary Aid Hospital, which existed in College Road next to Newton Hall, has now been converted into flats. The building, which had previously been a large private house, served from 1914 to beyond 1920 as a hospital for military personnel injured during the First World War. Local organisations supported it with voluntary contributions, and the patients were kitted out with light-blue trousers and jackets.

The soup kitchen in School Road off Union Street is now incorporated into Wolborough Primary School. A plaque on the wall describes its purpose in more desperate times. It reads: 'The freehold of this building was purchased in the year 1908 by Mrs Henry Jacob (née Hatch) in memory of the Revd Henry Tudor, sometime Rector of Wolborough, in cooperation with whom she started the Wolborough Sick and Soup Kitchen, in the year 1867.'

Before the present hospital was opened by Mrs D. Scratton on 29 November 1898 the cottage hospital was on the site of Cross's furniture store in East Street. The hospital was established in 1873 and had accommodation for thirteen patients. The rooms on the first floor, to the right of the steps leading to the auction rooms, housed the women's ward and operating theatre. The room at the top of the steps was the men's ward and a private chapel was on the left; a mortuary was at the bottom of the steps.

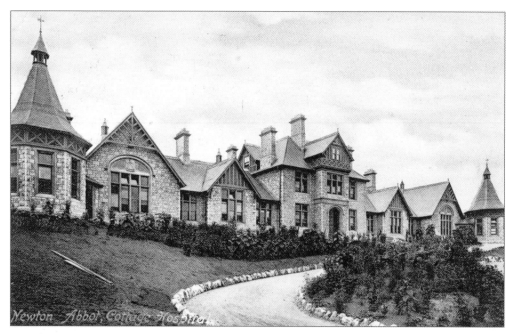

In December 1886 Mr D. Scratton purchased Long Orchard and presented it to the town as a site for a hospital. The building was paid for by voluntary contributions from local firms and dignitaries. The main benefactor was Mrs Fisher of Abbotsbury House who built the hospital in memory of her late husband, at a cost of £6,000. Sadly she died before it was completed.

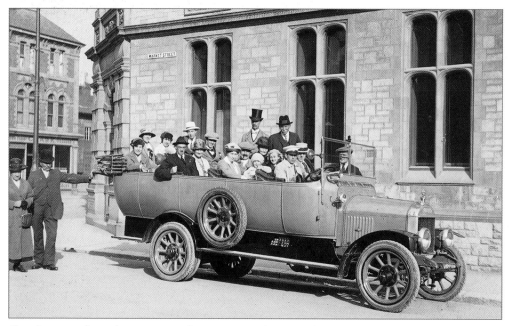

Charabancs such as these were used to transport the more fortunate on trips to the moor and to the outlying villages. With everyone sporting such an array of headgear it is just as well that the speeds were limited! This was one of the smaller models: some charabancs could carry thirty or more passengers.

4

Industry

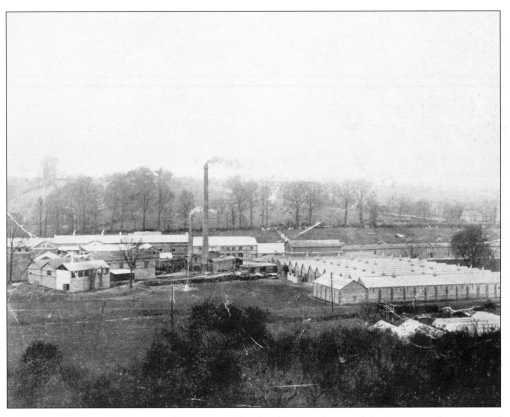

During the eighteenth century the Branscombe family owned a wool business on the corner of Halcyon Road. Then in 1786 ten-year-old Moses Vicary, accompanied by his mother, arrived in Newton Abbot to inherit his father's wool business, which was eventually moved to the site of the old Bickford's paper mills at the end of Bradley Lane. In 1837 the Vicarys bought out the Branscombes, and in spite of the fact that the mill was destroyed by fire (in 1883 and 1921, for example), it was rebuilt and continued as a major employer of about 300 workers, until it finally closed in 1972. This picture of the New Bradley Mills, as it was known, was taken in about 1933, after part of the tanyards closed in 1929–30.

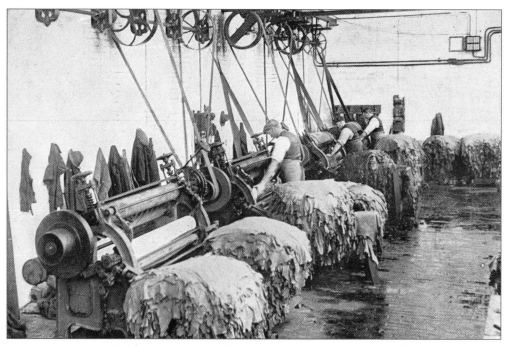

The Vicarys became involved in the leather industry as far back as 1837, when Samuel Branscombe sold his tanyards in Bradley Lane to them. This picture of workers at the mill was presented to the town's museum by Mr P. Heath's family. He was born in 1893 and worked at the mill for four years from the age of sixteen, earning the grand sum of 14s per week.

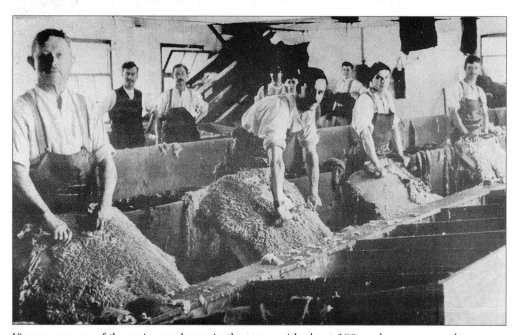

Vicarys was one of the major employers in the town, with about 300 workers – men and women – being in constant employment at the mill. The work was varied but hard. In this picture from the 1930s we see wool being pulled from sheepskins in the pulling shop.

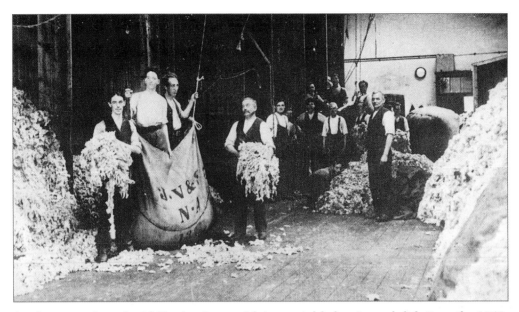

Another scene from the 1930s showing wool being sorted before it was baled. From the 1940s until the mill closed in 1972 lorries heavily laden with bales of wool emerging from Bradley Lane were a common sight. The wool was sent on to other areas for further processing.

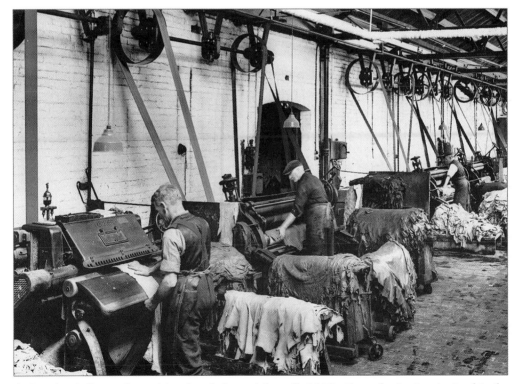

A view that indicates the variety of work done at the mill, 1960s. It was fascinating to stand in the doorway and watch the wool being cleansed and spun. Other jobs, such as this, involved treating the skins after the wool had been removed.

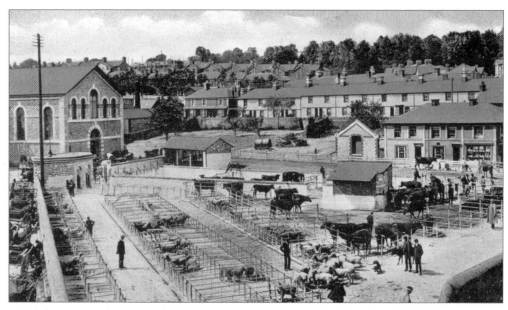

Before the nineteenth century the market was held in the open thoroughfare in Wolborough Street. When that market was abolished in 1826 the owner, Mr Lane, purchased Lydis Meadow at a cost of £3,000. When the Local Board was formed in 1864 it immediately took steps to purchase the market for the town. The animals were originally all penned together in one area, but when the present cattle market was built in 1938, cattle, horses and poultry were separated. The area in this picture became the market square.

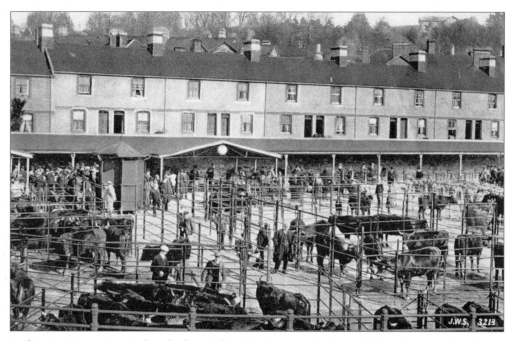

In this picture we can see that the livestock market has now been pushed further towards Halcyon Road, yet the sheep and pigs are still in the same area as the cattle – which dates the photograph to before 1938.

Originally there were two stations in Newton Abbot, one for the main line and one for the branch line to Torquay. This rare picture from the early 1900s shows horses and carriages outside the main line station waiting to transport travellers into the town or to outlying villages. The present entrance and offices were erected in 1928.

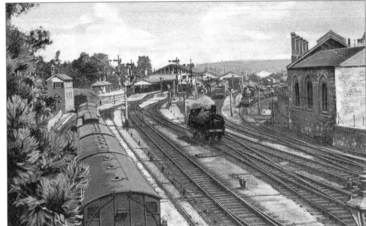

The railway played an important role in the town's development at the turn of the century. To the right we can see the engines waiting to leave the engine sheds, having been cleaned and serviced, ready to pick up their trains – which often changed engines here on their journey between Paddington and Cornwall. The little tank engine in the centre of the picture is most likely working as a pilot, whose job it was to divide or join carriages which had journeyed up from the Torbay branch line.

The arrival of the railway in 1846 changed Newton Abbot dramatically. By 1857 the total population for Newton Abbot and Newton Bushel was still only 4,600, whereas now it has reached over 23,000. A large carriage and wagon repair works adjoined the sheds in Forde Road. A favourite pastime of many inhabitants was to sit on the wall in Station Road watching the trains go by. In the distance stands the power station with its cooling tower, identifying the picture as being after 1940. Other differences from today are that the signal box stands between the lines, and the platforms were much longer.

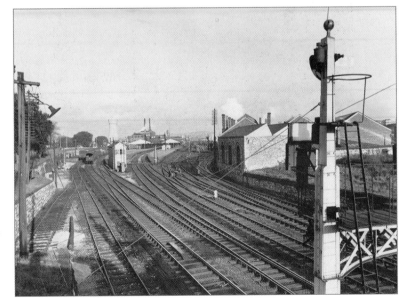

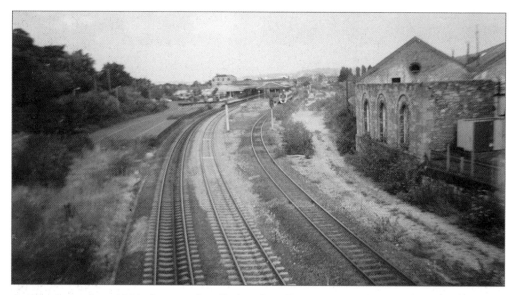

As this picture from 1989 shows, rail traffic has dwindled considerably, with both passengers and freight making more use of the roads. Being no longer needed, the lines leading to and from the engine sheds were lifted, and so were the crossover lines which enabled pilot engines to link trains. Other alterations included the removal of the signal box and the signals, and the shortening of the platforms. In comparison with its heyday the overall appearance is of complete desolation.

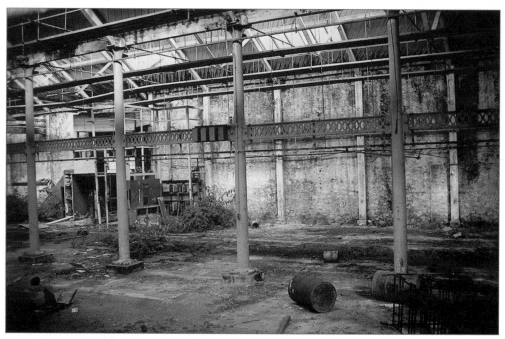

This shell of the disused British Rail maintenance sheds in Forde Road reminds us how important a part the railway played in the development of the town. It was one of the biggest employers with about 600 workers who were engaged in all manner of trades, including footplate staff (cleaners, firemen and drivers), office workers, engineers, porters, shunters and all the ancillary trades such as carpenters and builders. All contributed to the smooth running of the railway.

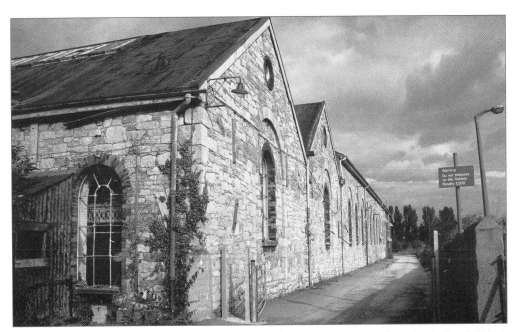

It is only recently that any work has been done on the ruined engine sheds in Forde Road. This is how they looked in 1990, and sadly they look even worse today. This was the exterior of the carriage and wagon works which existed for almost half a century. It was a sad day in 1965 when the factory hooter sounded for the last time. At one time the railway workers were summoned to work by a bell attached to a cottage which stood on Station Bridge, just about on the site of the present car park for David & Charles.

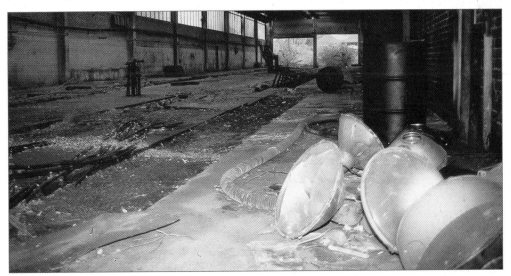

From such pictures we get a glimpse of what working in the engine sheds really meant. 'The Black Hole of Calcutta' is a phrase which readily springs to mind, for in those times there were no such luxuries as canteens or shower facilities, and men would return home from work covered in the day's grime. This picture shows the inspection pits into which it was necessary to crawl in order to climb up under the engine, to clean the gears or to carry out repairs. With the entrance at the end being the only means of light, all this work was carried out by the illumination from tiny oil lamps.

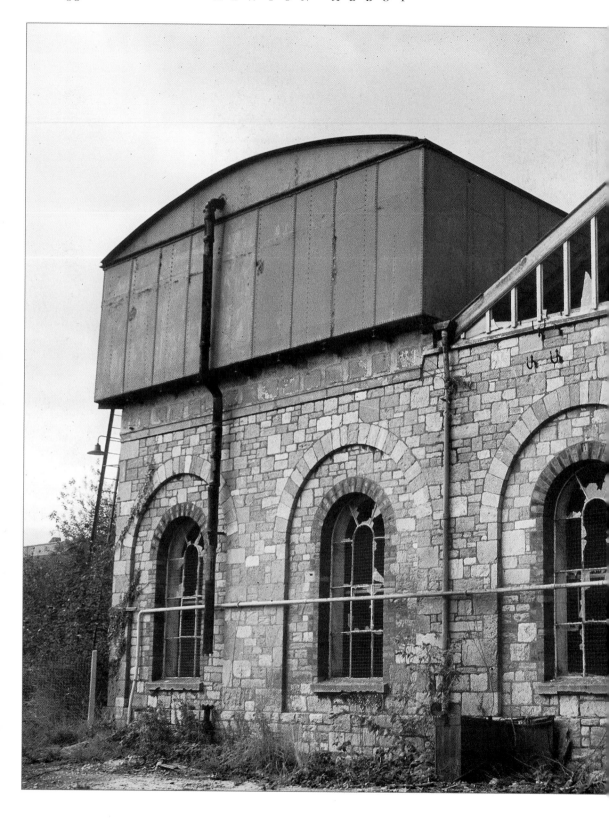

This large water tank, measuring about 45ft by 20ft by 10ft and situated above the engine sheds, was an outstanding feature of the railway. It was hoped that it might be preserved as part of the local private lines. However, not only was it too large for such humble needs, it also proved too difficult to dismantle and set up again. Sadly, such monuments to a very proud industry will soon only remain in photographs.

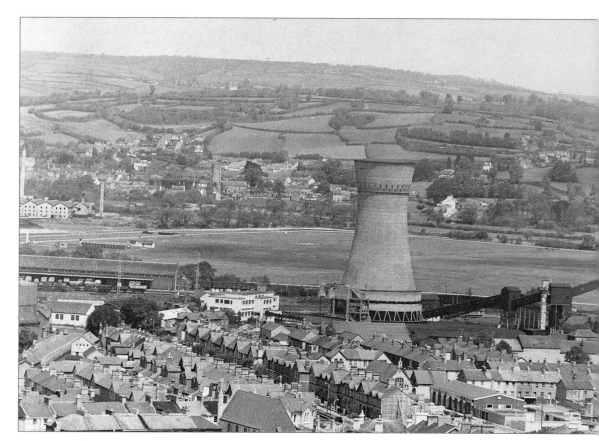

From 1940 the power station cooling tower was a prominent feature on the Newton skyline. As soon as you caught sight of the tower you knew you were being beckoned back home. Before 1924 the town received its electricity from Torquay, and one of its prized possessions was a Bellis and Morcom steam engine which came from the original Torquay power station at Beacon Quay. This piece of machinery served as an emergency means of starting up the system after a total shutdown. The boilers of Newton power station were coal-fired by a moving belt grate, and the station consisted of four low-pressure, four medium-pressure and four high-pressure boilers. As early as March 1888 discussions had taken place about electric sheet lighting for the town, and this was installed at the turn of the century. By the mid-1930s Torquay had made Newton Abbot its main generating station. By February 1949 all street lamps were operating on time switches, which made redundant the old lamplighter who used to cycle around the streets armed with a long pole. In 1973 there was bitter resentment when the last seventy-three employees learned that they were about to lose their jobs, even though there had been many

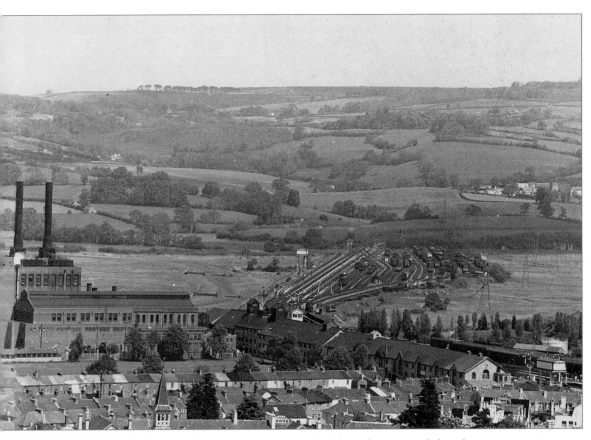

discussions of the closure for several years. Even so, there had been hopes raised that the power station was going to be converted to gas turbine operation, but this never materialised.

It is clear that this photograph is part of a panorama over the racecourse and Hackney marshalling yards. Since Hexter Humpherson Brickworks can be seen, the picture must date from the late 1950s. Houses still existed on both sides of Osborne Street, with no sign of the present car park. Built in 1911, Hackney marshalling yards played a large part in the country's railway system, handling about 40,000 wagons a week. For a while in the 1960s it was hoped that this facility would be increased, but in 1966 the first steps of the run-down of the town as a rail centre began. In April of that year parts of the yard were closed, and by 1980 it was barely functioning, with abandoned milk wagons being left there to deteriorate.

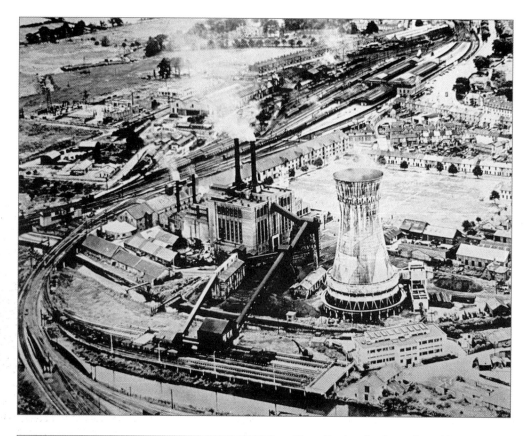

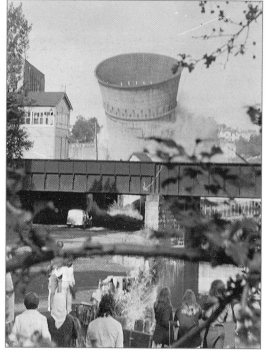

Above: During the Second World War attempts were made to camouflage the cooling tower by painting the outline of houses on its surface – but it is doubtful whether many enemy aircraft were fooled. Here we get a wonderful view of the area from Station Bridge in the top right-hand corner, across the complete site of the power station to the coaling platform in the bottom left. The Templer housing complex now stands on the site of the power station, while the coaling area has been converted into recreation grounds.

Bystanders congregate at the racecourse and Newton Quay in 1974 to witness the demolition of the cooling tower, which had been such a dominant landmark for over thirty years.

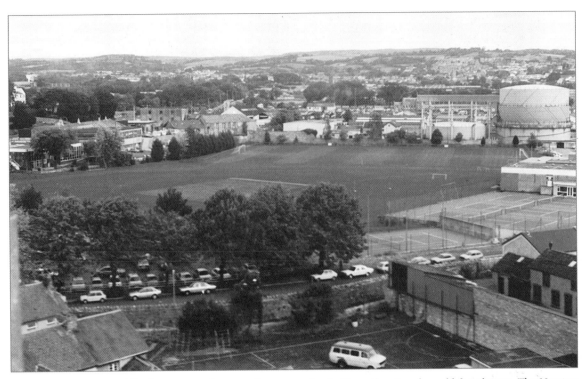

On the right in the middle distance can be seen the gas works, built on the site of an old farmhouse. The Newton Gas and Coke Co. was established in 1893 when Messrs Rendles Symmons offered a number of shares in the company. This picture from 1987 shows the main buildings and the smaller of the two gasometers, with a capacity of 200,000 cu ft of gas, which was erected in 1895. The other, with a capacity of 400,000 cu ft of gas, was put in place in 1937.

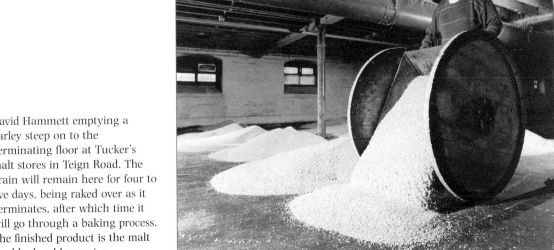

David Hammett emptying a barley steep on to the germinating floor at Tucker's malt stores in Teign Road. The grain will remain here for four to five days, being raked over as it germinates, after which time it will go through a baking process. The finished product is the malt used by local breweries.

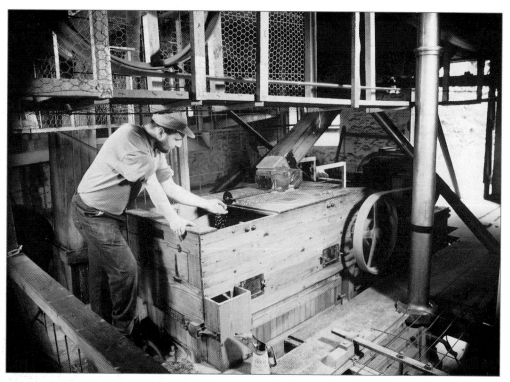

Malcolm Hammett operating a barley screen, which sifts and screens the barley before it is finally turned into malt. Tucker's mill has been functioning here for over a century, and has employed generations of families.

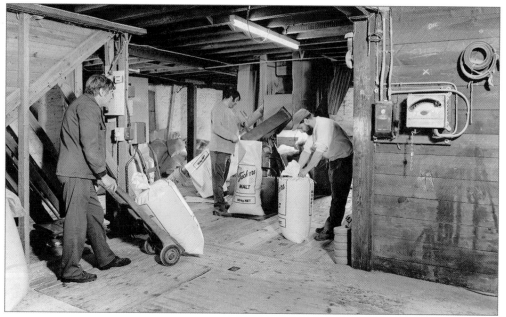

The malt is bagged up and distributed to local breweries. Many employees, such as Les Hammett, handling the wheelbarrow, have spent practically the whole of their working lives in the industry.

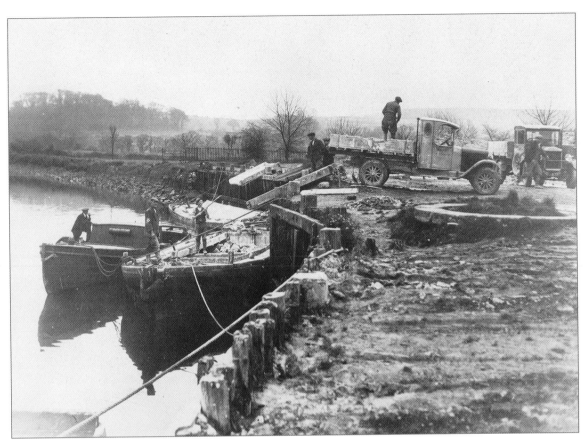

Generations of Newtonians were aware of the benefits to be derived from the two local rivers, the Lemon and the Teign, long before the railway arrived and offered a more direct route to the rest of the country. During the seventeenth and eighteenth centuries the town was recognised as an inland port, with ships of considerable size registered locally and forming part of the Newfoundland fleet. Various reminders of this industry have lingered on to present times in such names as St John's Street, Newfoundland Way, the Jolly Sailor, the Devon Arms, the Dartmouth Inn and the Newfoundland public houses. Other memories of the trade have been revived, such as here at the Quay, which was renovated and then reopened, by Councillor Mrs Hewitt, on 6 August 1988. Restoration of this area was first proposed in 1981 when Newton Abbot Town Council entered into negotiations with the Central Electricity Generating Board to purchase land, but the Board withdrew. Later the town was granted a ninety-nine year lease by the District Council. The opening event in 1988 also commemorated the development of Templer Way, to celebrate the part played by the Quay in conveying granite from Dartmoor and clay from the surrounding mines to different parts of the country. On the plinth in the picture a crane once stood for hoisting cargo on to the ships and barges, and at the reopening of the Quay a granite capstan was erected bearing a plaque to record the occasion. Sadly this plaque has since been vandalised but many people are grateful to enjoy this additional recreation area. It is interesting to note that when the centre of the crane-base in the picture was excavated, a solid elm post that was part of the original was discovered, even though nothing of the original had been seen above ground for over a century. This scene of Newton Quay from the 1930s includes various aspects of industry, with the clay being shifted between trucks and barges, and a good view of the plinth in the foreground.

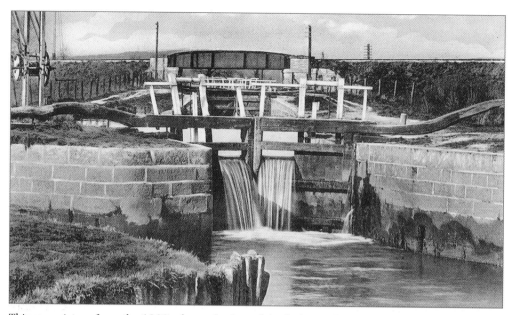

This rare picture from the 1900s shows the last of the locks on the canal and Whitelake Channel, just before it spills into the River Teign. We can locate it by relating it to the railway bridge in the background, carrying the line over the river. This area has now been transformed into a recreation ground.

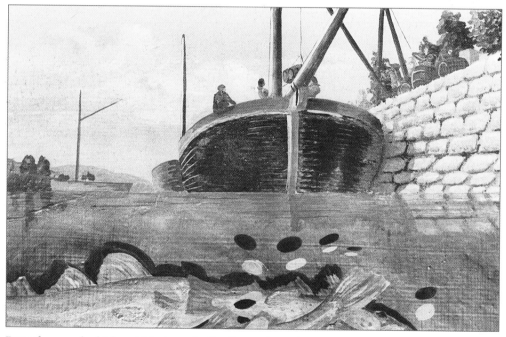

Part of a mural which used to hang in the Devon Arms (now Strikers) in East Street, showing a boat being loaded at the wharf. Men would meet at various public houses such as the Devon Arms, Newfoundland Inn and the Jolly Sailor to sign up for a year-and-a-half trip to the New World. The picture illustrates the crane being used in loading cargo. Fish was stored in several places throughout the town, and it was customary for ancillary trades to receive fish as part payment.

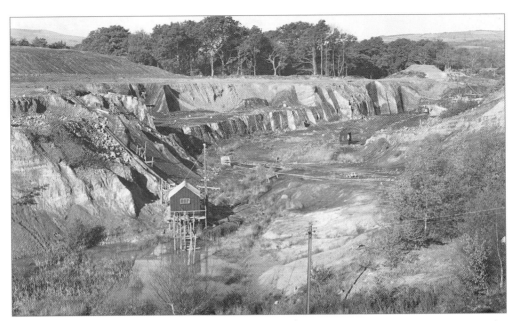

Ball clay is used in many of our everyday products, and was transported from Devon to the
Potteries in the north of the county, particularly Stoke-on-Trent. The size of this local mine can be
seen by comparing the figures and buildings with the trees around the perimeter of the pit.

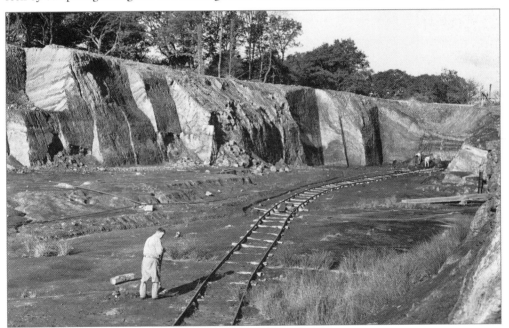

Clay has been mined in Devon for over 300 years. During the eighteenth century clay was mainly
mined in the Bellamarsh area where it was most accessible, covered by less than 3ft of topsoil. But
as demand for a high standard of product increased, production became more sophisticated and
workers dug deeper to reach higher grade materials. Shaft mining began in about 1870, with
24 sq ft pits being sunk, heavily timbered to prevent collapse and reaching depths of about 80ft.
Adit or horizontal shafts were also dug.

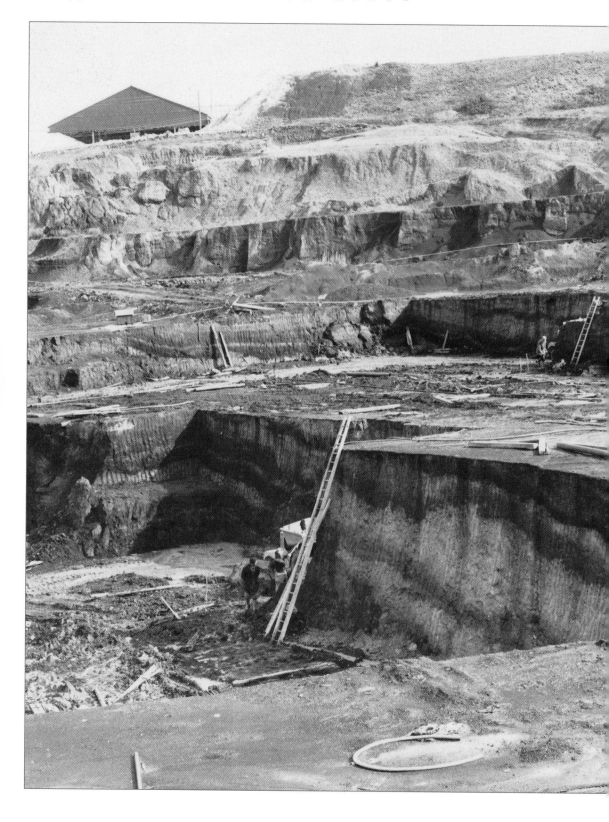

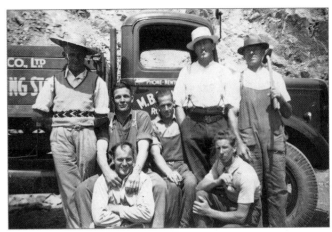

Rydon Quarry in Kingsteignton, 1937, long before there was any thought of the nearby dual-carriageway. Included in the picture, loaned by Mrs Hocking of Moretonhampstead, are: Ron Emery (driver), Bill Davey, Taff Pritchard, Fred Noyce, Ernie Dire, Walt Davey (driver) and Charlie Ryan.

All clay mining in the area is now open-cast rather than through shafts or adits. This picture gives us an idea of the depths to which men had to descend underground. The figure in the centre of the pit in the foreground in contrast with the horizon helps us to appreciate the amount of earth which would have been above him.

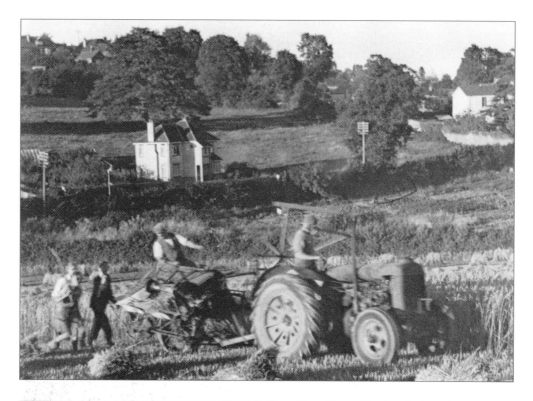

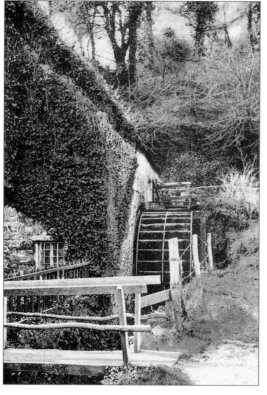

Above: Harvesting in what was known as Farmer Dadd's fields, adjoining Ashburton Road, 1940s. After 1946 the area on the far side of the road became Laurie Estate, developed by a consortium who built their own homes, while the fields in which this harvesting took place became Bradley Barton Estate. The Ashburton Road, from Broadlands to Mile End, runs right across the centre of the picture.

As delightful as this unusual scene of Ogwell Mill with its water-wheel in the centre of Bradley Woods might be, it reminds us that this was a working mill. Today very little of the ruined mill remains, but it is a pleasure to visit the site and visualise what life must have been like just a century ago.

5

Sports & Recreation

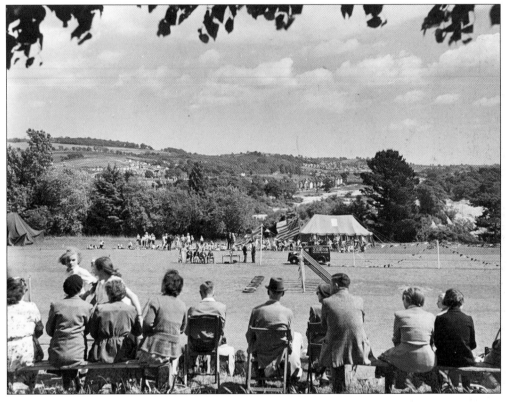

With so many recreational sites within the vicinity of Newton Abbot it is not surprising that sports featured so prominently in the town's development. Rugby has been played here since the middle of the nineteenth century, and the cricket club was one of the first to be established in the country. The schools have contributed much to the development of sport, and some great sportsmen have come from the town, even some who have been chosen to play for their country. Sports day has always been an important feature in the curriculum of the schools, and in this picture from the 1960s we see a sports day on the playing fields in Coach Road. In the middle distance on the right we can see that the Devon and Courtenay Clay Company, which was still in operation, while in the distance Milber and Kingskerswell were awaiting development.

The bowling green in Courtenay Park was opened in April 1921. It was at the annual meeting of the club at Phillips' Restaurant in February 1924 that ladies were present for the first time. In 1922 it was agreed at a general meeting to spend £70 on relaying a portion of the green with moorland turf. This might help us to date this picture, as the middle lanes look as if they are being treated.

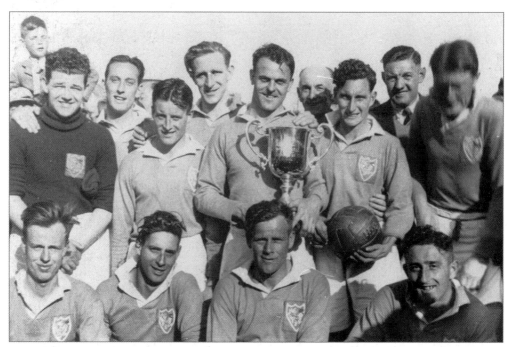

With a score against Bishopsteignton of 9–0 these members of the Newton Spurs Team of 1945/46 proved themselves worthy winners of the Herald Cup. The back row includes Stuart Mountford, Eric Butler, Stan Watkins, Gordon 'Doc' Emmett, Fred Stopp, Terry Waye and Ken Pascoe. In the front row are Jack Collier, Ernie Prowse, Cliff Taylor and Vic Randall.

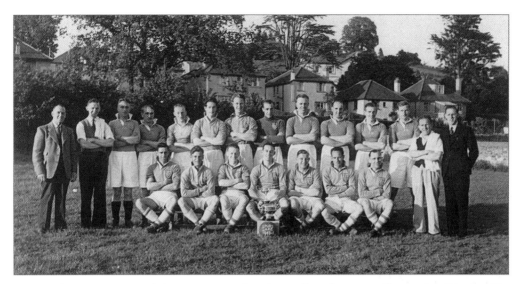

In 1947/48 Newton Spurs' first team was the Plymouth and District Charity Cup Winner. The team included Jim Butler, Harold Davey, Tom Shaw, Jack Bush, Sam Bostock, George Burley, Ron Bailey, Jack Collier, Len Rowe, Fred Melhuish, Dave Naylor, Mr Dore, Frank Harris, Ernie Prowse, Len Richards, Arthur Owen, Eric Butler, Alec Lindop, Reg Prowse and Roy Foster.

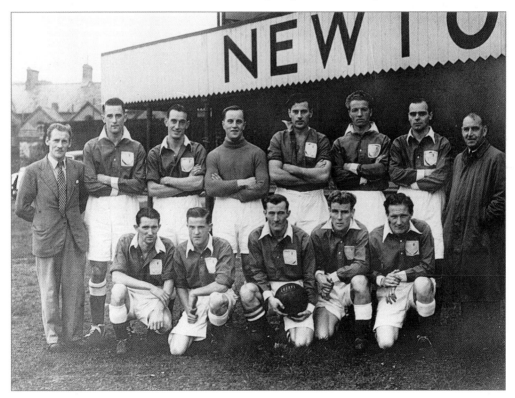

The First South Western League Team for Newton Spurs in 1951/52 included Bob Mercer, Bill Strudwick, Eric Butler, Mr Vidgeon, Mr Lawrence, Harry Butler, Charlie Smith, Jim Butler, Mr Davies, Bill Anderson, Alfie Beeson, Mr McMasters and 'Wiggy' Hamley.

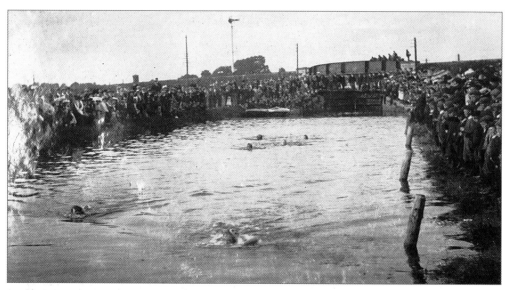

Until June 1935, when 3,000 local people attended the opening ceremony of Penn Inn swimming bath, youngsters from the town had to resort to using the locks on Stover Canal as a venue for their galas. Even so, the Otter Swimming Club had already proved itself to be a worthy water polo team. As far back as 1896 Kingsteignton Parish Council had been asked about erecting a shed near the canal to accommodate the bathers. In Newton Abbot Museum is a series of photos from 1908 showing the first Aquatic Sports being held in the canal, but in spite of such obvious need, efforts to build a pool two years later failed again. However, the debate continued, and in 1919 the town discussed the offer of a site at Jetty Marsh, owned by Councillor J. Dolbeare, and in 1924 the chance to construct a pool on a bend in the River Teign was still being talked about.

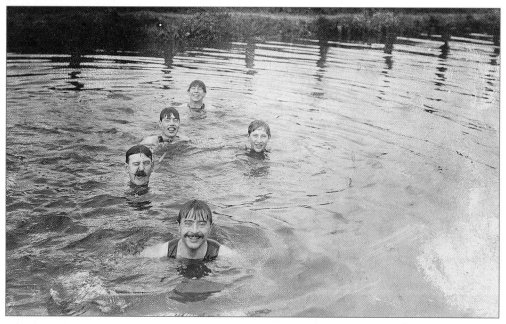

A happy group of participants swimming in the canal, very likely at the first Aquatic Sports in 1908. Only the most intrepid would be able to keep smiling under such conditions.

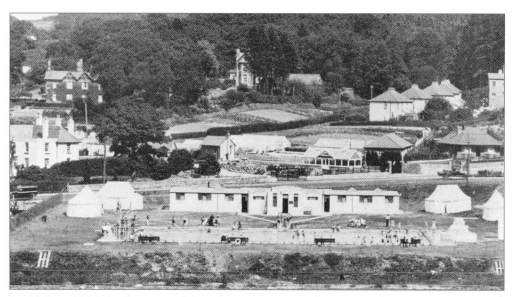

On 13 June 1935 the chairman of the Urban District Council, Mr Leonard Coombe JP, officiated at the opening ceremony of Penn Inn Pool, the money to pay for the project raised by public subscription of 1d per week from most wage packets, with more generous donations from the wealthy. Most of the work was performed by those who were previously unemployed in the area. This is the pool shortly after it was opened. Note the changes which have occurred since. Who remembers the nurseries on the corner of St Marychurch Road? The changing tents on the left of the picture were for men and those on the right were for women, while the more affluent members of society had access to cubicles within the building at 6d per time.

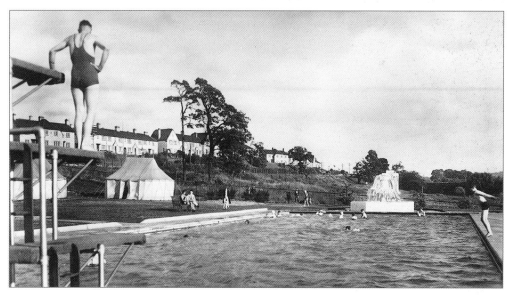

Many Newtonians learned to swim at the pool, with most schools from the area holding weekly lessons during the summer months. Consequently it came as a bit of a shock in 1965 when, as a result of many injuries nationwide, diving was banned at the pool. At first some diving was still allowed from the lower boards and the springboard, but later this was also stopped, together with diving from the side of the pool.

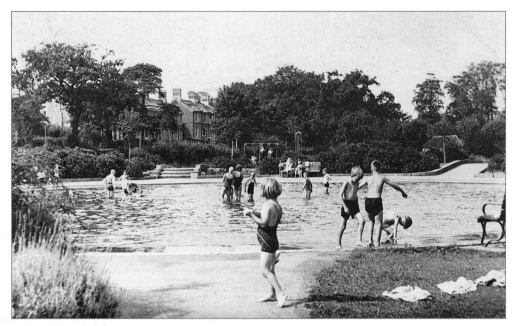

Generations of Newton's youngsters enjoyed their first introduction to swimming in the paddling pool at Penn Inn Park. Here in the 1950s we see the joy they experienced in the water, which was only about a foot deep at its deepest in the middle. Note the swings and other play amenities in the park behind the pool.

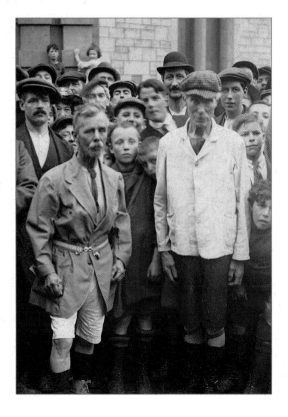

Athletics were very popular in Newton Abbot, with records of athletic meetings being held at South Devon Cricket Club on Whit Monday 1886. Many local influential men were present. One amusing incident occurred at a meeting in 1891, with reports of an official being fined for starting a race with a pistol. Apparently the Chancellor of the Exchequer felt that excise laws had been infringed. Because of restrictions on the use of firearms, they were not even allowed in stage productions without prior permission. The back of this postcard records that on the same day as this race a boy cut his leg and had one stitch.

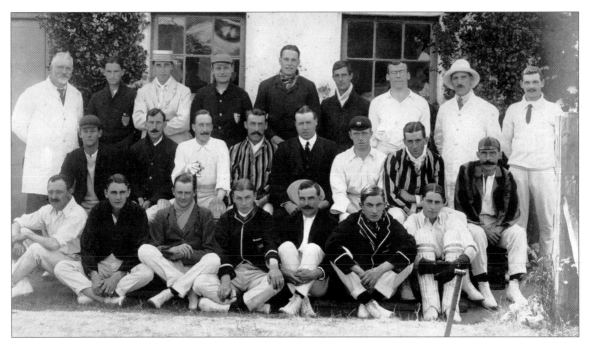

Cricket is one of the oldest sports played in Newton Abbot. Its origins in the town can be gleaned from a report in the *Mid-Devon Advertiser* for August 1899, which traced the formation of the club back to 18 May 1823. This picture shows members of Teignbridge and South Devon Cricket Club at Teignbridge in about 1910. No report on the town's association with the sport would be complete without reference to Len Coldwell, who died suddenly in August 1966 aged sixty-three. As a lad Len was a regular participant in football and cricket at Baker's Park, and went on to play for Worcester and his country. His finest hour was at Lord's in 1962 when he bowled England to victory over Pakistan in his test match debut. He was part of the 1962/63 team that went to Australia to play in the first two tests in 1962.

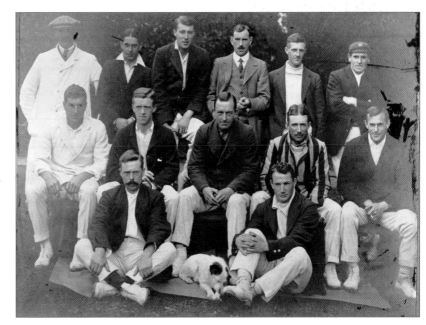

Although no one would question the enthusiasm of these members of the South Devon and Teignbridge Cricket Clubs from about 1913, it is doubtful whether their performance was enhanced by indulging in so much tobacco! However, their success as a club was well known, in that during the 1899 season of twenty-two matches, they won fifteen, lost three and had four matches unfinished. In 1921 it was reported that a professional had been engaged for the season.

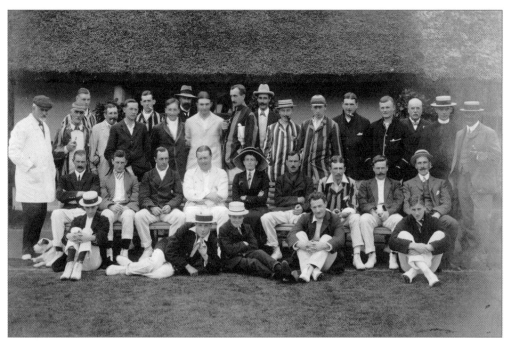

In 1890 the original Ladies' Cricket Team was scheduled to visit the town to play an exhibition match between eleven gentlemen and twenty-two ladies. This picture of the South Devon and Teignbridge Cricket Clubs dates from about 1912.

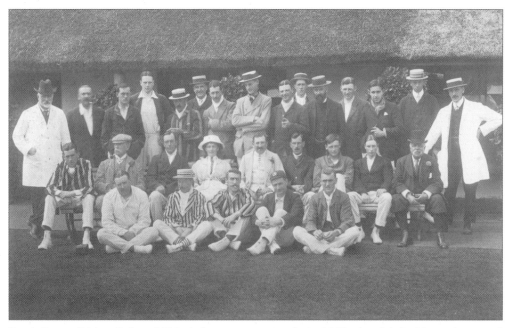

South Devon Cricket Club, *c.* 1912. A few years previously, in 1899, the club had been threatened with eviction from their ground. Their attitude towards their sport is expressed in the report that every member was required to be at the ground to support the claim to remain; every member who did not attend would be fined 5*s*, and those who were late would be fined 2*s* 6*d*.

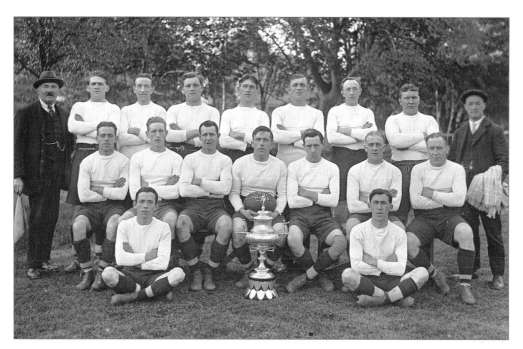

The formation of Newton Abbot Rugby Football Club can be traced back to 1879. At first the club played at Newton Marshes but it transferred to the recreation ground in 1897. Of particular importance was the visit of the New Zealand All Blacks in 1924. In 1923 the club won the Devon Senior Cup, beating Torquay Tics in the final by seven points to nil. This is the 1923 team, consisting of Alf Hugo, Tommy Emmett, Bill Mole, Henry Hugo, Simmonds, Percy Dave, Sid Bond, Joe Facey, Len Taylor, Chas Hambly, George Rowse, Bill Hambly, Warren, Bill Tozer, Harry Hooper and Bill Phillips. The officials are Bob Stephens and Harry Bunclark, and the Devon Senior Cup rests proudly at their feet.

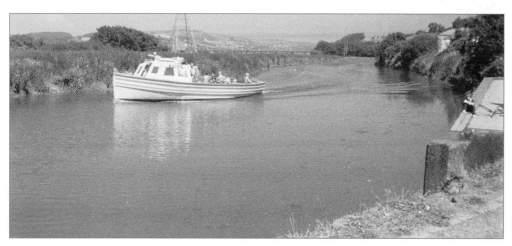

Although previously industrial, both banks of the River Teign have now been transformed into recreational areas that attract rambling, birdwatching and many other social activities. On the south side, part of the Templer Way route runs beside the river to Teignmouth. The river itself is enjoyed by the local boating fraternity and also visitors on trips up from Teignmouth as far as the confluence of canal and river near the Kingsteignton bridge.

Just off Greenhill Way, Hackney Marshes Nature Reserve has been established on the north side of the River Teign. A pathway leads along the derelict Hackney Canal towards Passage House Inn. Along the pathway, just before it passes under the dual carriageway, are the ruins of Hackney Village, which until the 1920s was occupied mainly by men who worked on the barges that were used to transport clay along the canal. Many bird species can be observed, including a flock of white egrets which have become established in recent years.

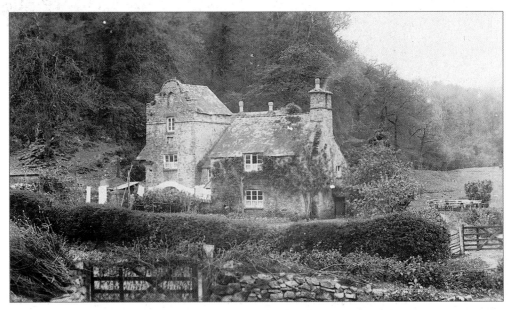

Many Newtonians ease the stress of modern living by strolling through Bradley Woods. Sadly Ogwell Mill no longer exists, but the scenery is still as attractive as ever. Many features remind us of how life used to be. A visit to Bradley Manor House, Puritan's Pit, the ruins of the mill, the mill leat, the limestone kilns and their quarries all help us to trace the course of Newton Abbot's history from medieval times to the present day.

This weir, which emptied the overflow from the mill leat back into the River Lemon, is probably one of the most photographed scenes in Newton Abbot. Although this picture dates from the beginning of the twentieth century, the scene has changed very little and is just as attractive today. Just beyond the weir, towards Bradley Manor House, is the 'wishing well', whose waters are reputed to hold healing qualities for those with eye problems.

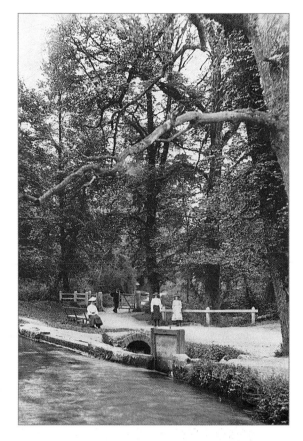

The basic layout of Courtenay Park has altered very little since it was purchased by the town in 1897 from the Earl of Devon. The railings surrounding the park were erected in 1890. Not everyone was pleased with them, and in 1914 and 1915 there were complaints from tenants in neighbouring houses about the noise of the gates clanging at night. In the background can be seen the old railway station, which helps to date the picture to the 1920s.

This picture probably dates from the 1950s, for by now the entrance gate and railings have been removed from Courtenay Park. A further clue to its date is that white lines have appeared in the centre of Station Road, indicating the increase in traffic.

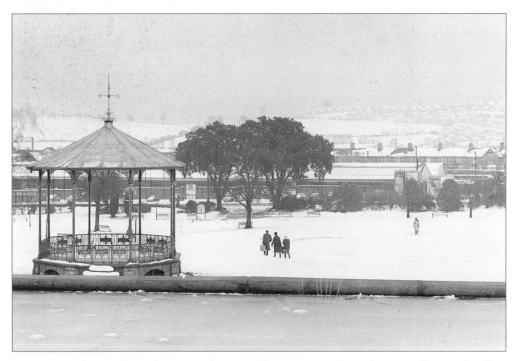

'Footsteps in the snow' is a fitting conclusion to this section as these three travellers trudge their way across Courtenay Park to the railway station. It isn't often that we get a lot of snow in this area, which helps to date the picture to the winter of 1960–61. The fact that the fish pond appears to be frozen over emphasises that this was no overnight flurry.

6

People & Celebrations

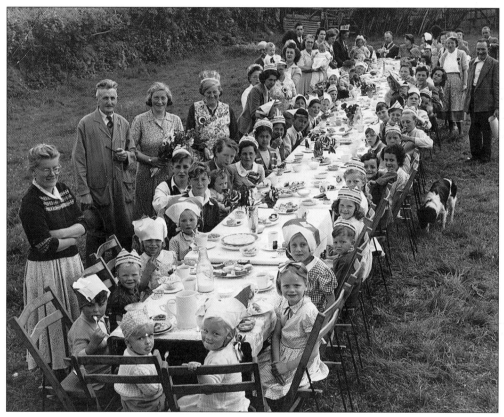

The people of Newton Abbot have always shown a desire to celebrate whenever there was a major event to share. This is expressed in the way generations have always gathered at the clocktower to hear reports of national interest. During the middle of the twentieth century, after six years of world misery and gloom, they were eager to demonstrate their joy – but after years of austerity it was strange for some to 'let their hair down'. Consequently, in comparison with some of today's celebrations, their efforts might appear to be somewhat sombre and bland. Uppermost in many minds was the desire to compensate the children for what they might have lost; therefore a street party was a favourite activity. Here we see the inhabitants of Greenaway Road enjoying such an event, with the chairman of the council at the head of the table. Judging by the way the helpers are sporting rosettes and some of the girls are wearing striped hairbands, this party seems to be to celebrate the coronation of Queen Elizabeth II. The location is the field at the end of Greenaway Road – now Noelle Close – owned by Mr and Mrs Miller, who are standing second and third from the left. Mrs Miller has been presented with a bouquet to mark the occasion.

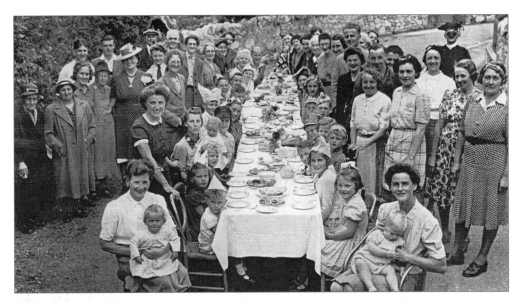

Such was the relief at the end of almost six years of war that almost everyone, even the smallest communities, wanted to get together to celebrate in 1945. Here the residents of Vale Road show their joy at Victory in Europe.

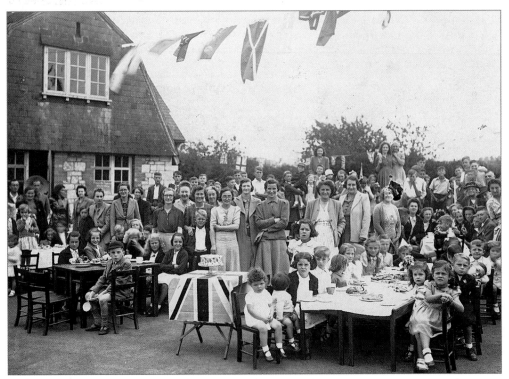

With peace in Europe at 2.41 a.m. on 7 May 1945, these residents of Decoy at Decoy Primary School on 9 May were determined to be one of the first groups to celebrate the occasion with a party. In spite of rationing still being in operation until 1952, the heavily laden table and the celebration cake show the lengths to which the residents were prepared to go to show their delight.

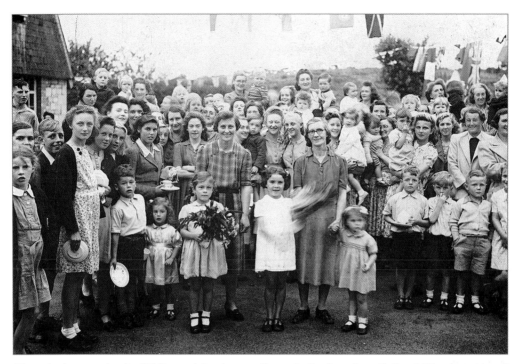

Of particular note in the VE Day celebrations at Decoy is the fact that all the children are turned out smartly in their best clothes, with hardly a hair out of place and their faces freshly scrubbed. It is also interesting to see how the children clutched their own plate, cup and saucer, which they had obviously been asked to provide for the occasion.

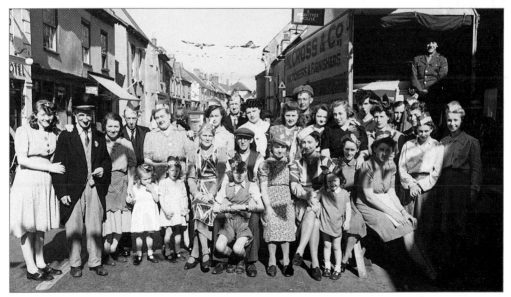

The residents of East Street certainly knew how to throw a party, as is demonstrated here at their VE celebration in 1945. It was a case of *entente cordiale*, with the America soldiers supplying the music and Messrs Cross the transport or 'stage'. Many members of the Cross, Paddon and Bearne families can be seen here along with their neighbours.

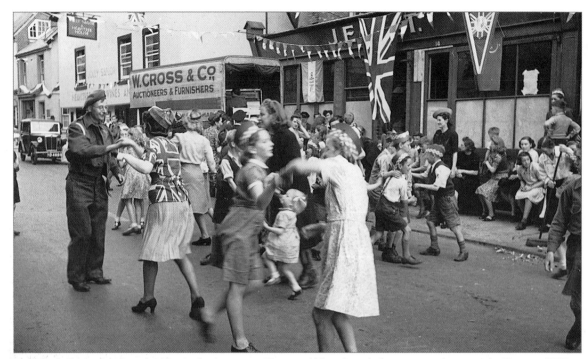

This shows how the idea of a 'disc jockey' came to Newton Abbot, long before any modern trends. Here on VE Day in 1945 it seems as if the 'jitterbug' was already a craze enjoyed by local people. In the background is Cross's delivery van serving as a makeshift stage for the sound equipment.

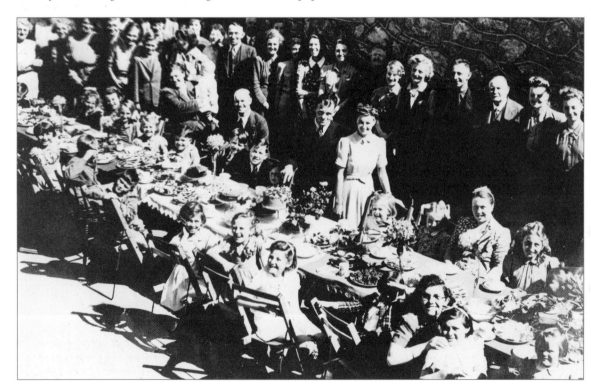

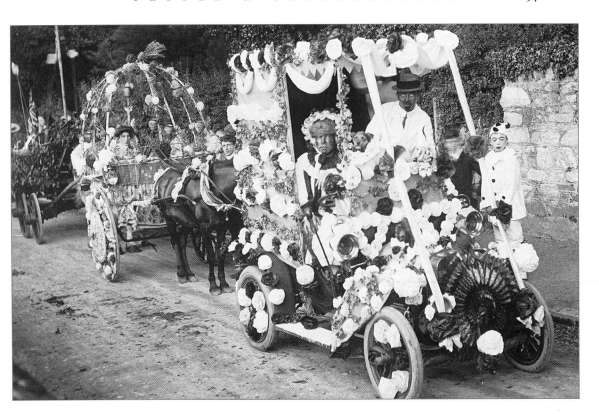

From its construction in November 1898 Newton Abbot Hospital, opened by Mrs D. Scratton to commemorate the Diamond Jubilee of Queen Victoria, was supported by voluntary subscriptions. The following June it was reported that Hospital Saturday – a procession in support of the hospital – had proved to be a huge success, and it was hoped that it would become an annual event. This picture shows the effort that participants were prepared to put in to support the event.

Opposite, below: The inhabitants of Halcyon Road in jubilant mood as they take part in a street party in celebration of VJ Day, 1946. Such parties were a 'must' to enable people to relax after six years of constant fear and anxiety. In spite of the smiles on their faces, though, no doubt many were nursing heartaches as a result of the war.

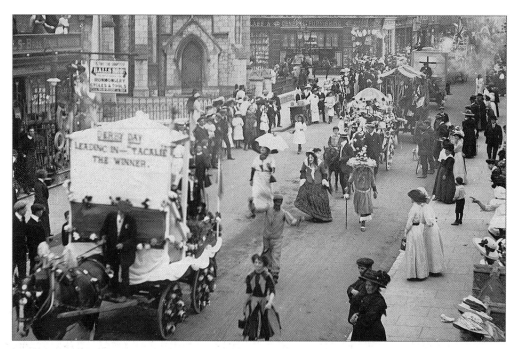

The Hospital Saturday procession wound its way through the streets and parks of the town, drawing in competitors from the neighbouring towns and villages. This procession of 1912 gains the admiration of onlookers as it passes by the Congregational church in Queen Street.

The original determination to make Hospital Saturday an annual event was continued until 1948, when the National Health Service was introduced. The event included a fête held at Dyron's in Old Exeter Road, the home of the Vicary family. Many sideshows, stalls and competitions gave a carnival atmosphere to the whole day.

The registration of this Mini Moke dates the photograph to about 1965. Many local firms travelled to the various fêtes and carnivals, not just to advertise, but also to enter into the spirit of the festivities.

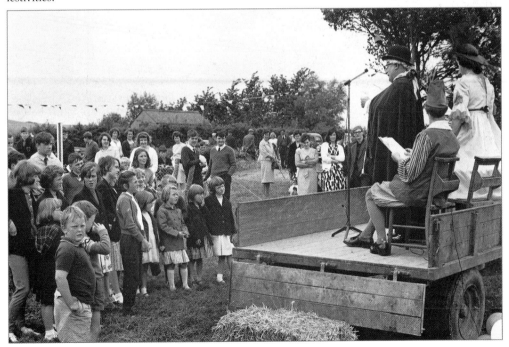

These youngsters appear mystified by the participants in drag.

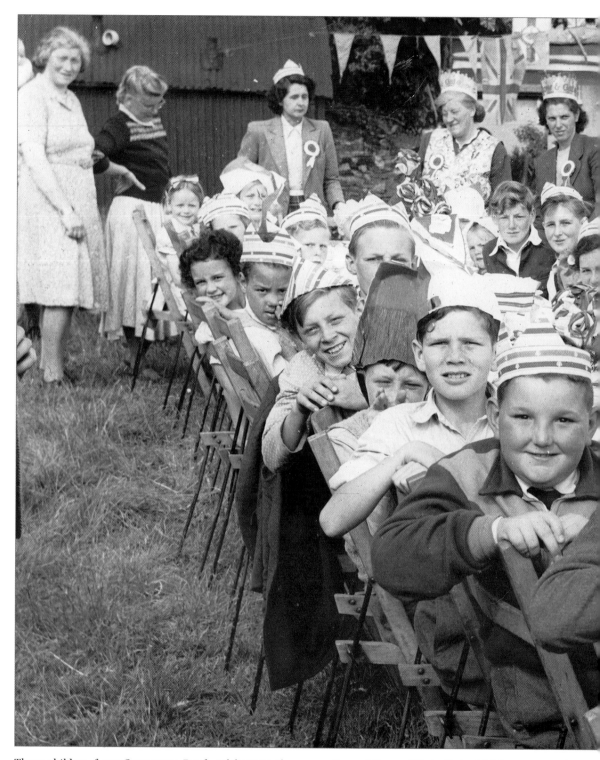

These children from Greenaway Road, celebrating the coronation of Queen Elizabeth in 1953, appear rather apprehensive as they pose for the camera. It is strange to think that many of them are themselves now

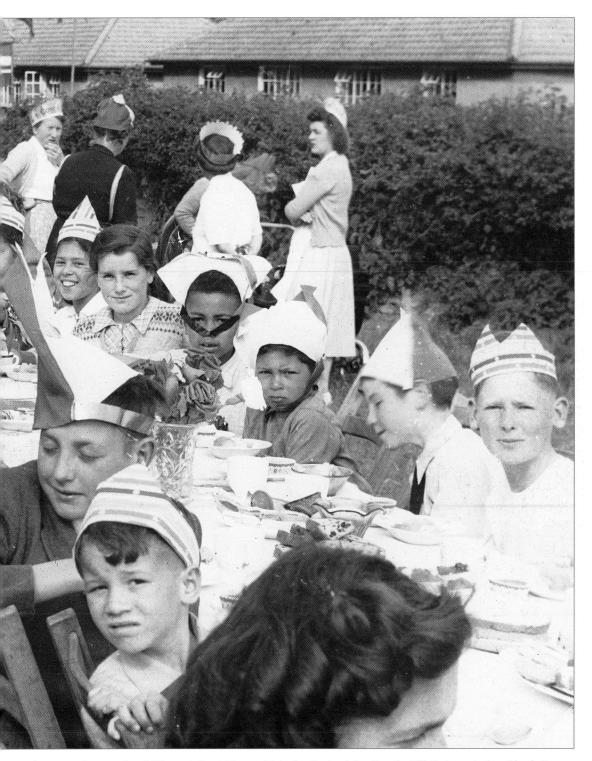

grandparents. Among the children at the table are Malcolm Darke, John Beavis, Bill Stainer, Arthur Lloyd, George Bray, Ann Bray, Janet Simpson, Jean Simpson, Barbara Bray, Ken Simpson and Leroy Simpson.

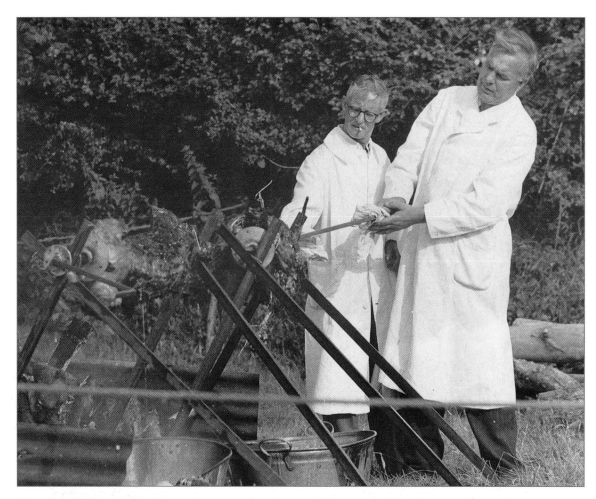

The origin of Kingsteignton's annual ram roasting fair is said by some to be in Druid sacrifices. However, others trace it to the reign of Henry II when the manor of Whiteway gave its name to a son of De La Torfe who had married the heiress of the manor. Because he was otherwise engaged in London and unable to be part of the festivities when the boy got his majority, the Lord of the Manor instructed that the inhabitants should celebrate the occasion with an unlimited supply of bread, beef and ale which should be provided for all. The Bell Inn and the King's Arms public houses were to run free drinks for forty-eight hours. He also stipulated that they should catch the largest and fattest sheep and roast it whole on the Green. Whatever the origin, there was a break in the event during 1939 to 1945, but it was restarted in 1946.

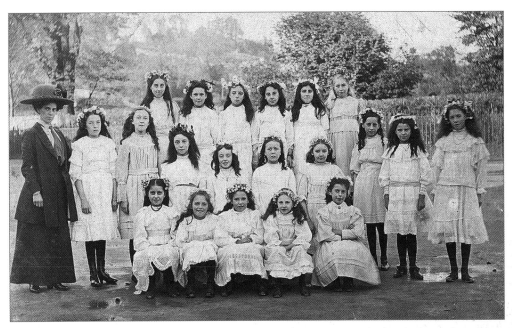

The girls of Bearne's School decked out in their finery to celebrate May Day, *c.* 1910.

Many local firms would often reward their employees with an end-of-year luncheon. Among them was Candy's Tiles of Heathfield, seen here entertaining its workers in about 1953.

This youth parade photographed by Mr Edworthy, chairman of Newton Abbot Urban District Council, was most likely part of the victory celebrations at the end of the war. Many Newtonians will remember with fondness Beven's Restaurant at the junction of Queen Street and Devon Square.

Since this march-past at the war memorial involved both military and civilian personnel, it was probably part of the unveiling ceremony of the backdrop on 21 June 1949 by Earl Fortescue CB, OBE, MC, JP, and Lord Lieutenant of the County of Devon.

7

Newton Abbot at War

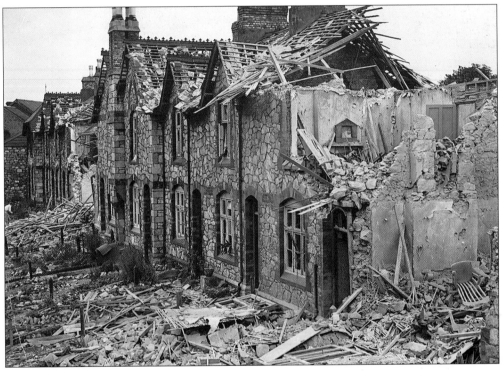

South Devon Terrace after being bombed during the first air raid on Newton Abbot railway station, August 1940.

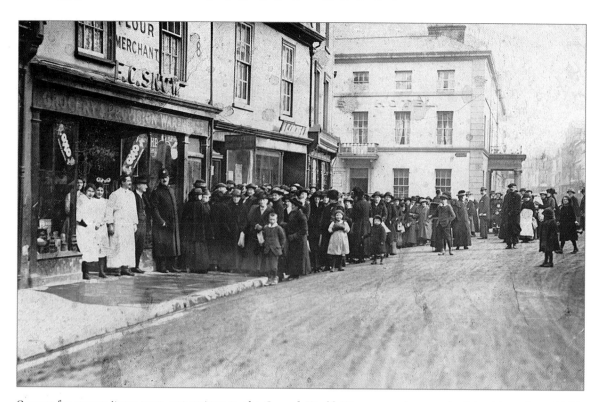

Queues for scarce items were not unique to the Second World War as can be seen in this picture from 1914. Queues stretch right along Wolborough Street, across Bank Street and down Courtenay Street past the Globe Hotel: they are waiting for a supply of cocoa and butter at Snow's grocery store.

Opposite, below: The crowd follows in procession along Wolborough Street where, after the presentation by Lord Hambledon who was resident in North Bovey, the tank and field guns were escorted to a site in Baker's Park. Here they remained until they were taken for the scrap metal campaign in April 1940.

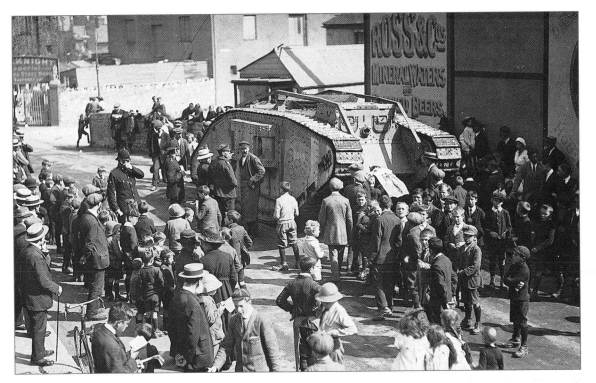

Hero's Bridge, 11 September 1919. A crowd gathers in the summer sunshine to inspect the German army tank and two field guns which had been captured by 5th Battalion of the Devonshire Regiment in 1918, and had been on display for a couple of months before being presented to the town. In the background is Knight's Monumental Masons, which used to be on the left of Kingsteignton Road.

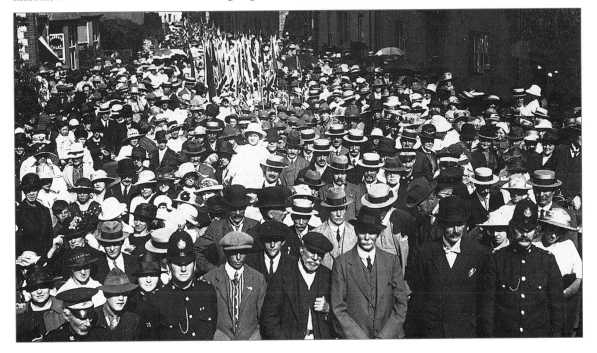

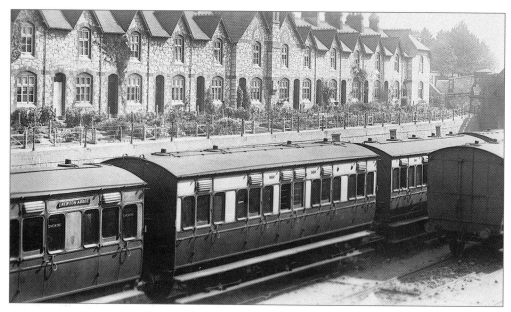

South Devon Terrace, Forde Road, more often referred to as Station Cottages, in the first decade of the twentieth century. There were two rows of these houses, and we can see how attractive they were with their neat, tidily kept gardens facing on to the railway. The picture on page 105 shows the destruction caused to the terrace by a bombing raid in August 1940.

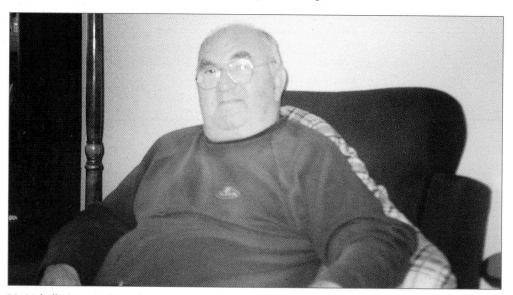

Mr Melville 'Nuggets' Northcott, whose fifteen minutes of fame came at 6 p.m. on 20 August 1940 when, as a young lad, he became the first civilian in the town to be shot by a German machine-gunner. At the time he lived at 17 South Devon Terrace, known as Station Cottages in Forde Road, which were bombed in the first raid on the station. During the raid one Newtonian was killed along with fifteen other people who were waiting in a stationary Plymouth-bound train, and fifty more were injured. The vegetable market became a temporary mortuary. The second bomb attack on the town occurred on 22 April 1942 when five people were killed, many were injured and much structural damage occurred.

Form E.M.S. 105.

MINISTRY OF HEALTH

EMERGENCY MEDICAL SERVICES

Notification in respect of all Civilian Casualties and Service and Police Cases (Sick or Casualties) admitted to Hospital

To be completed in the case of all service personnel (see paragraphs 5, 6 & 7 on cover).

Personal No. (Officers)
Service or Official No. (Other Ranks)
*Warrant No.

Rank*Civilian Casualty*....

Unit, Corps or *Division

** Applies to Police Officers only.*

Name (Surname)*Northcott*.... *of 17 Station Cottages*

(Christian names)*Melville*.... *Newton Abbot*

Place, Unit, or Hospital †from which received*Air Raid at Newton Abbot Railway station*....

† The full address and code number of the Hospital should be given.

Date of admission*20 August 1940*....

Date of discharge

Date of death

Diagnosis*Fractured ulna*

‡Degree { Slight. Serious. Dangerous. }*caused by Machine Gun bullet*....

‡ Delete those not applicable.

Name and Address of Hospital rendering report*Newton Abbot Hospital*....
Code No 8722*Newton Abbot*....

Signature NEWTON ABBOT HOSPITAL

Date*21 August 1940*....

Mr Melville Northcott's admission form, presented when he was admitted to Newton Abbot Hospital in August 1940 – after he was shot by a German machine-gunner on the first bombing raid on the railway station. The admission card was issued by the first-aid post which treated Mr Northcott before he was admitted to the hospital.

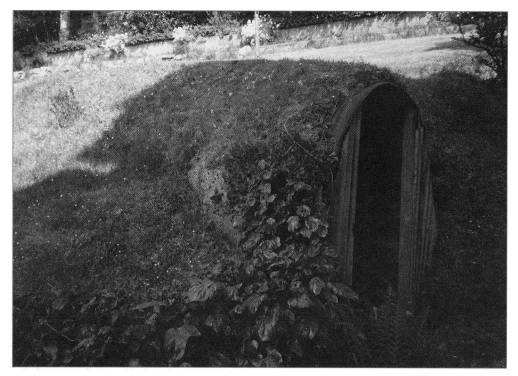

Air raid shelters like these, relics of the Second World War, can still be seen in some local gardens. This photograph was taken in 1995 in a garden in Penshurst Road, off Coach Road.

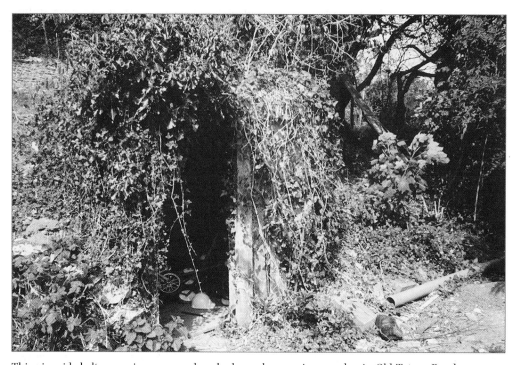

This air raid shelter, serving as a garden shed, can be seen in a garden in Old Totnes Road.

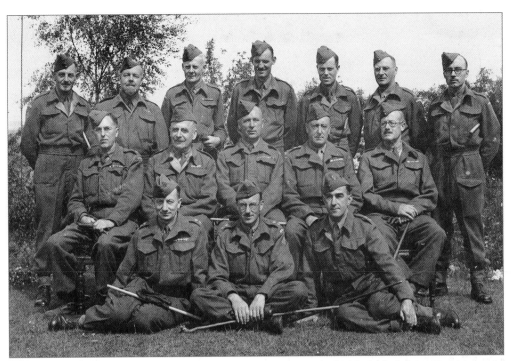

Officers from 'A' Company, 9th Battalion, Devon Home Guard, 1943. Included in the picture are Lieutenants Foster, Staniland, Bradley, Whiteway-Wilkinson, T.L. Read, Hack and Harding, Captains Austin MC, W.T. Mason, Lieutenants Coleridge, Veale MM and Woodward.

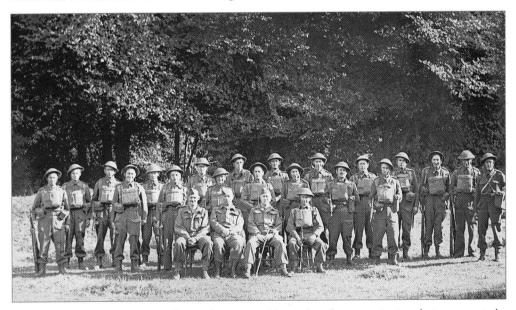

These men from 'A' Company, 9th Battalion Devon Home Guard on exercise in what appears to be the meadow in front of Bradley Manor. The officers in the front row are, from left to right, Captain R.C.F. Whiteway-Wilkinson, Captain C.E. Austin and possibly Captain G. Ormrod. They certainly posed a formidable force to be reckoned with, and what they might have lacked in stamina and ability was compensated for by their enthusiasm.

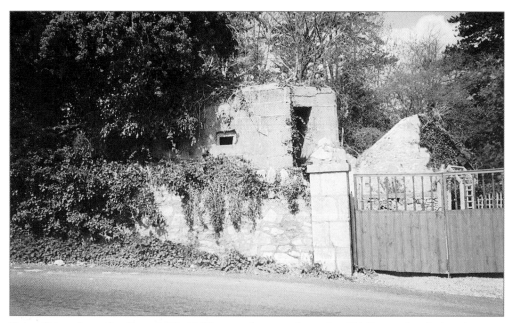

This pill-box from the Second World War can be seen from the Old Totnes Road. Another one remains in the garden of a house on Churchill's Estate, adjoining Bovey Road, just after the new roundabout from Jetty Marsh Road.

It was with such concrete cones as these that the Home Guard were determined to prevent Hitler's panzer divisions from occupying the country. They were huge lumps of concrete surmounted with an iron ring for hauling, and they were spread across the road as a barrier. Two of these tank traps lay discarded in Jetty Marsh Lane until the construction of the new road, and have now been used as a feature to mark an entranceway. A large collection of them has been discovered in woods near Channing's Wood Prison.

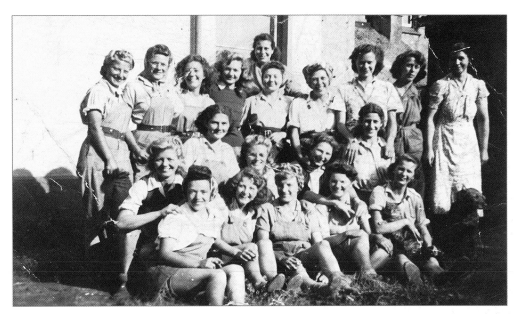

During the war years everyone was expected to do their bit. Many houses around the town were impounded by the forces to accommodate service personnel and those employed in similar work. This group of Land Army girls was resident in Courtenay Park, in a house now serving as offices for the clay firm Watts, Blake and Bearne.

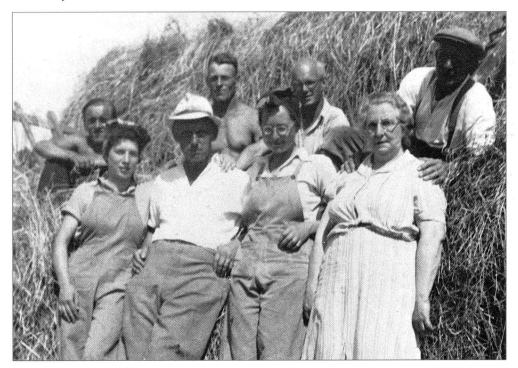

This photograph was loaned by Mrs Joan Kitt. Among the workers with Mr and Mrs Ludwig at Luscombe Farm, Chudleigh Knighton, are Joan Kitt, her colleague Gwen, Fred Oshea and two German prisoners of war. The owners themselves had fled from Eastern Europe.

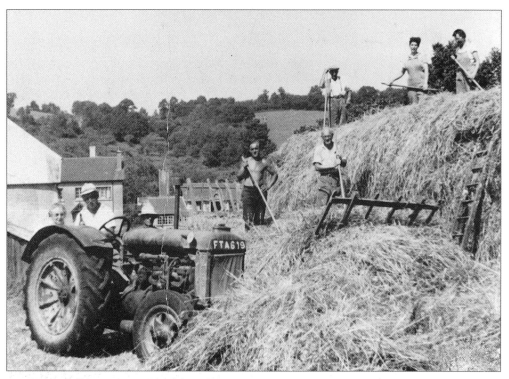

In spite of the war great camaraderie existed between the farmers, Land Army girls and the POWs, who in 1945 can be seen working together to bring in the harvest.

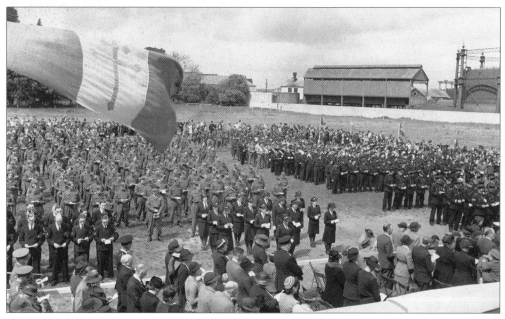

A combined commemorative service at the Recreation Ground, Newton Abbot, during the Second World War. The fact that the Home Guard are still prominent in the centre of the picture possibly dates it to 1942–43.

8

Buildings & Places of Historic Interest

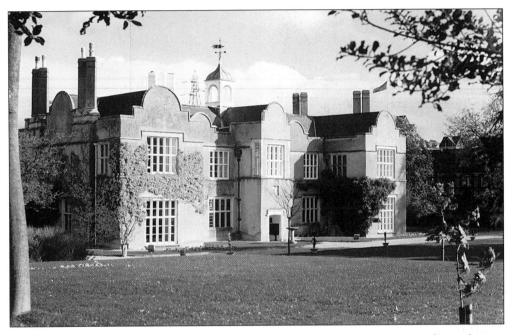

The fact that Newton's history extends back well over a millennium means that it has an abundance of interesting features which are all too often overlooked by the casual visitor. To see these features clearly one needs to peel back the veneer and see how and why a particular building developed in the way it did, why certain industries flourished in a particular manner, why they ceased, and what part they played in the country as a whole. Some very influential people have had their roots here and many important people have visited the town. One particular building which has entertained royalty on several occasions is Forde House on Torquay Road, originally constructed by John Gaverock in 1545 but then purchased and rebuilt by Richard Reynell in 1610. The present edifice bears the date 1610, which refers to the main part of the house. Like many houses of the time it was constructed in the shape of a letter E in honour of Queen Elizabeth I. In 1625 Richard Reynell entertained Charles I here while he was on his way to Plymouth to inspect the fleet. Later, in 1646, Sir Thomas Fairfax and Oliver Cromwell stayed here, and in 1688 William of Orange arrived as a 'guest' of Sir William Courtenay. In more recent times the house has undergone major restoration work through the efforts of its present owners, Teignbridge District Council, and was visited by Queen Elizabeth II on 2 April 1980, when she signed a book which is kept in the chairman's parlour. In front of the house stands an interesting lead waterbutt bearing the letters CWF and the date 1755. This was probably part of the renovations completed by Sir William Courtenay, who later became the 1st Viscount Courtenay.

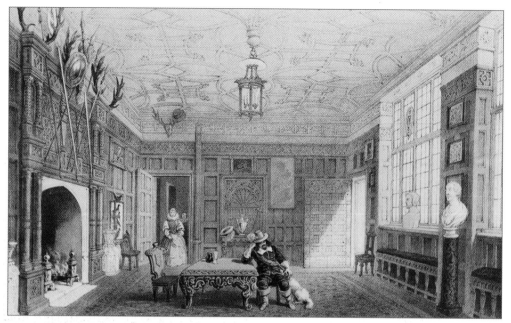

This 1847 lithotint by F. Hulme gives an artist's impression of Forde House during the sixteenth century. This is the main hallway in which can be seen an elaborate Jacobean chimney breast, while the stained glass windows portray the arms of the Reynell, Brandon and Courtenay families.

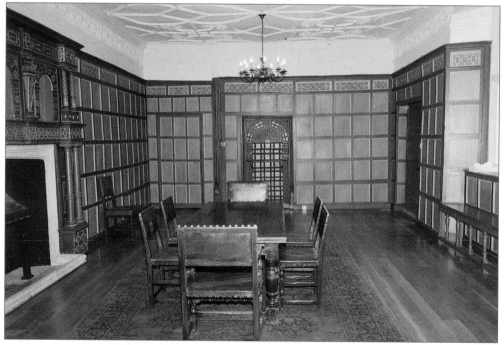

This picture of the hall taken in 1983 shows that it has changed very little during the past 150 years, and possibly looks very much as it did when it was constructed almost 400 years ago. The oak doorways and stairway, the finely carved panelling and ceilings have all been restored to reflect some of their former glory.

The rear of Forde House is vastly different in appearance from the front façade. This is the portion built by John Gaverock in 1559 on land which he had purchased from the abbots of Torre. He had been the steward in Manor House in Wolborough Street, but after the Dissolution of the Monasteries he purchased the town for a total cost of £592 14s 2d.

This rear portion of the house, constructed by John Gaverock, has flagstones on the floor and contains some Victorian furniture. It is alleged that this house was built on the site of an earlier building, which had been home to a group of nuns connected with Torre Abbey.

No. 6 Old Exeter Road, otherwise known as St Mary's Cottage, is probably the oldest ordinary residence in the town, and was built with wattle and daub. Under the plaster over the fireplace can be seen Tudor rose designs. Some of the walls are lined with wooden panels, which appear to have come from a ship. Instead of nails being used to join the rafters in the loft, the beams are held together with wooden dowels or pegs.

On the oak lintel above this medieval fireplace in 6 Old Exeter Road are several cuts which were obviously made with an adze. These, with many other indications, show that this house adjoining the school next to St Mary's can be traced back to Tudor times.

Other than the names of Castle Dyke Farm, Castle Dyke House and nearby roads there is very little to remind us that a castle existed in Teignwick, or Highweek as it later became. The only visible evidence is in this pile of rubble and stones surmounted by a group of fir trees. This was probably a wooden structure which, because of the burden of inheritance tax, was allowed to fall into disrepair. In 1237 Henry III gave Teignwick to one of his favourites, Theobald de Englishville, who was at the same time granted a weekly market and two annual fairs.

Castle Dyke Farm derives its name from Teignwick Castle. In spite of a Norman arch doorway much of the building dates from medieval times. The porch is quite interesting, with its side seats at the entrance. When the door is opened it reveals some marvellous wood panelling in the porch.

Milber Down Camp or the Celtic Camp, bisected by St Marychurch Road, and Berry's Wood Iron Age fort behind Bradley Manor are proof that life existed here in Newton Abbot long before the Norman Conquest. Milber Down Camp consists of four mounds in concentric rings, which are still discernible today, and are recognised as an enclosure for stock and safety. Contrary to some beliefs this was not a Roman fort, but it appears that it was used by some of the more affluent citizens of Isca (Exeter) as an outpost.

In 1937–38 excavations were carried out at the Milber Down Camp, and the relics identified it as being from a far earlier civilization than Roman. Among the artefacts found were brass ornaments and articles of pottery, and a bronze bird, a deer and a duck which can be seen in Torquay Natural History Museum.

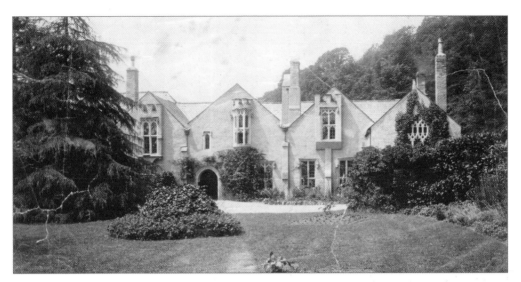

Bradley became the manor house of Newton Bushel in 1269 when the tenants, Henry and Matilda de Bickleigh, became the wards of the four-year-old Theobald Bushel, whose father had inherited Teignwick Manor from his uncle Theobald de Englishville. There was a dispute over this, but a Royal Commission found in Bushel's favour, and the Bushel family remained at Bradley until the last of the male line died in 1402, when it was transferred through the female line to the Yardes. The Bushels busied themselves in developing this older settlement of Teignwick, which became known as Highweek.

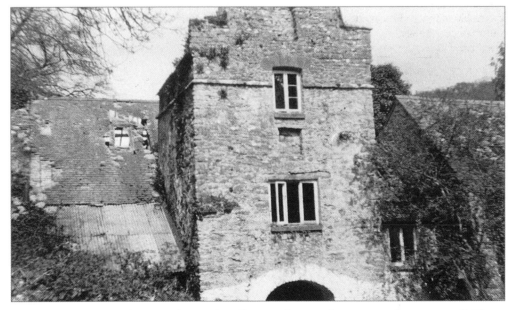

Ogwell Mill, situated right in the heart of Bradley Woods, was almost certainly a grain mill. This is one of the more picturesque scenes in Newton Abbot. However, when this picture was taken in 1924 the mill was already beginning to fall into disrepair, and today only ruins and a few millstones remain. However, if one searches around the location other signs, such as the water diversion, show how the water was used to drive the waterwheel. The building constructed on the ruins served as tea rooms for a number of years but is now a private residence.

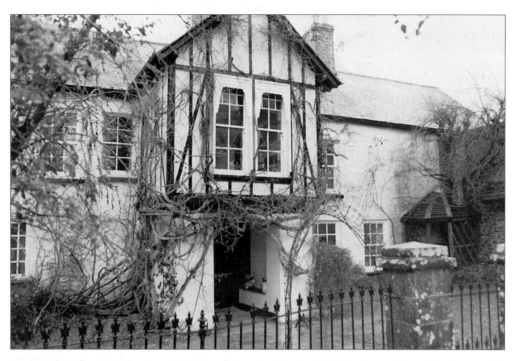

Ringslade House, Highweek, nestling in quiet seclusion just off the Bovey Tracey Road, was the home of the Segar family, who featured prominently in the affairs of Highweek and can trace their ancestry back beyond the sixteenth century. Just when this particular house was constructed is not known, but it seems to date from the seventeenth century. It is adorned with a large wisteria, which adds to the attraction of the house.

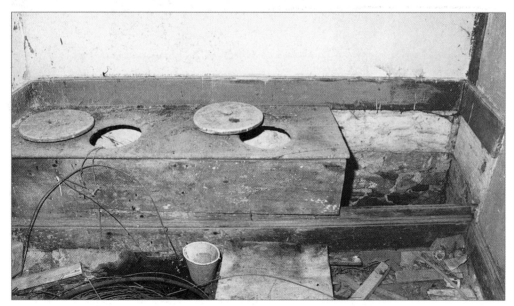

The barns and outhouses of Ringslade House could be even older than the house itself. This picture, taken in 1984, shows an interesting feature, a Victorian three-holer toilet in one of the outhouses: this gives us an idea of the relative harsh lives led even by the gentry.

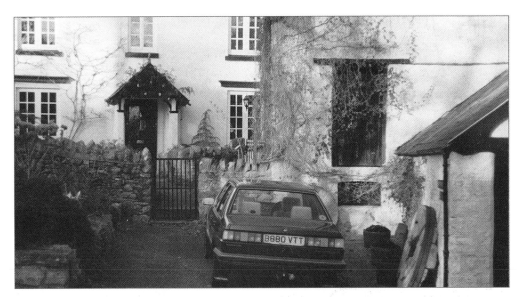

One of the outstanding features of Whitpot Mill on the Old Kingskerswell Road is that beside the old barns it still retains a working waterwheel. For years after it ceased functioning as a mill it was tea rooms, but perhaps its greatest claim to fame lies in the fact that it was once owned by Thomas Lee, the brother of John (Babbacombe) Lee, who became known as 'the man they couldn't hang'. Three times he escaped the scaffold, and later he spent some time visiting his brother here at the mill. Tom Lee's signature can still be seen on one of the beams.

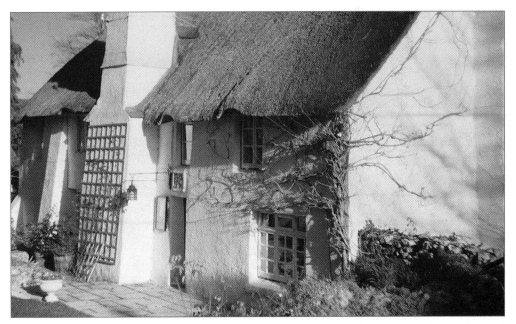

Pitt House in Kingskerswell, built between 1420 and 1440, is one of Devon's best-known licensed restaurants, but it is steeped in history. It is claimed that Sir Thomas Fairfax stayed here in 1646, and in 1688 when William of Orange was making his way up from Brixham the Prince dined here while waiting for his horse to be re-shod. However much credence is given to these stories one can't help but be impressed by the building's stone fireplace, the hall panelling and the oak-beamed rooms.

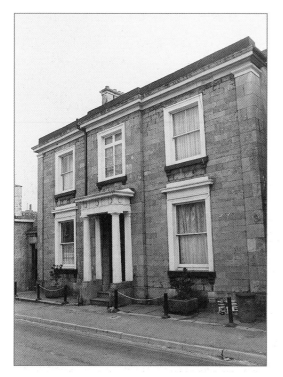

In 1715 the house on this site at 83 Wolborough Street was the home of John Lethbridge, a wool merchant who had fallen on hard times. In pursuit of a new venture he carried out experiments in his orchard, whereby he encased himself in a wooden cask and submerged himself under water for long periods of time. As a result he developed a method of diving to sunken ships, to allow the recovery of treasure from shipwrecks. This he continued for over twenty years, and even though he almost drowned on at least five occasions he was well rewarded for his success at diving to Spanish galleons, London galleys and ships belonging to the Dutch East India Company.

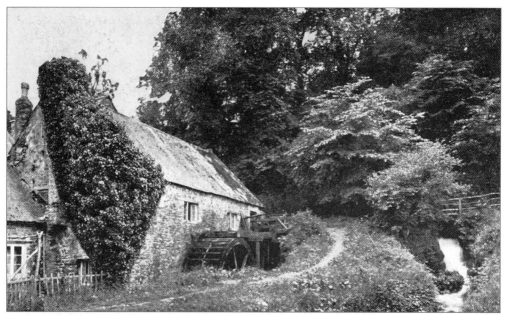

Such pictures as this of East Ogwell from about 1900 remind us of its close links with Newton Abbot. In more recent times development has almost brought East Ogwell into the town, and were it not for Bradley Manor House and Baker's park preventing further encroachment, the village would no doubt have merged completely. During the reign of Richard II the manor came into possession of the Reynell family, who built the present Forde House. In 1986 the Ogwell estates were sold to D.R. Scratton, whose support for Newton Abbot Hospital is well documented.

In 1545 the manor house in Wolborough Street, now the offices of the *Mid-Devon Advertiser*, was occupied by John Gaverock, the steward of the abbots of Torre, at a yearly salary of £3. When he built his new house at Forde, this one in Wolborough Street became the servants' quarters. Gaverock's manor was distinct from nearby Bradley Manor, which became the manor house of Newton Bradley. John Gaverock was succeeded by his three daughters, Elizabeth, Alice and Susan, who sold this part of their inheritance to Sir Richard Reynell.

The thick cob walls, the fine oak staircase and the magnificent plaster ceiling, adorned with foliage and Tudor rose design have long been thought to indicate that Wolborough Manor House was built in the sixteenth century. It wasn't until the *Mid-Devon Advertiser* occupied the premises that this medieval fireplace was uncovered. Notice the medieval carvings to the rear of the fireplace.

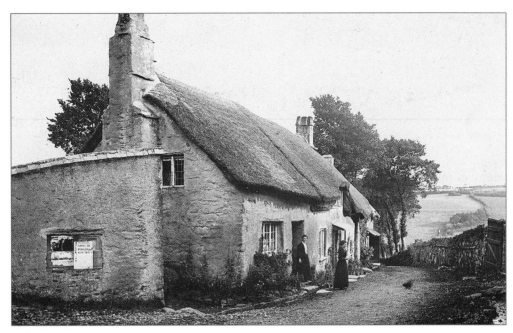

Although the women's dresses show that this is obviously a scene from about 1900, many of the houses in this attractive little village of Ilsington, on the way to Haytor, have not altered in appearance. A number of the cottages still have thatched roofs, and the white-washed cob walls make the village a fitting gateway to the moor. The notice attached to the wall seems to be advertising a poultry show in the neighbourhood.

The Manor House in Teigngrace, just outside Newton Abbot, is another residence which featured prominently in the Civil War of the seventeenth century. The Royalist-favouring rector, Joseph Challice, 'borrowed' the village children and took them into his own house. Cromwell's forces took pity on such a large family and left them alone. Details of this event are recorded in the nearby church, built by the Templer family in 1787. An interesting feature of this church is the large painting behind the altar by James Barry, which is a copy of Vandyck's *Pieta*, now in Antwerp Museum.